How to Draw Lifelike Portraits
from Photographs, Revised Edition

*Merry Christmas
from your
Librarians*

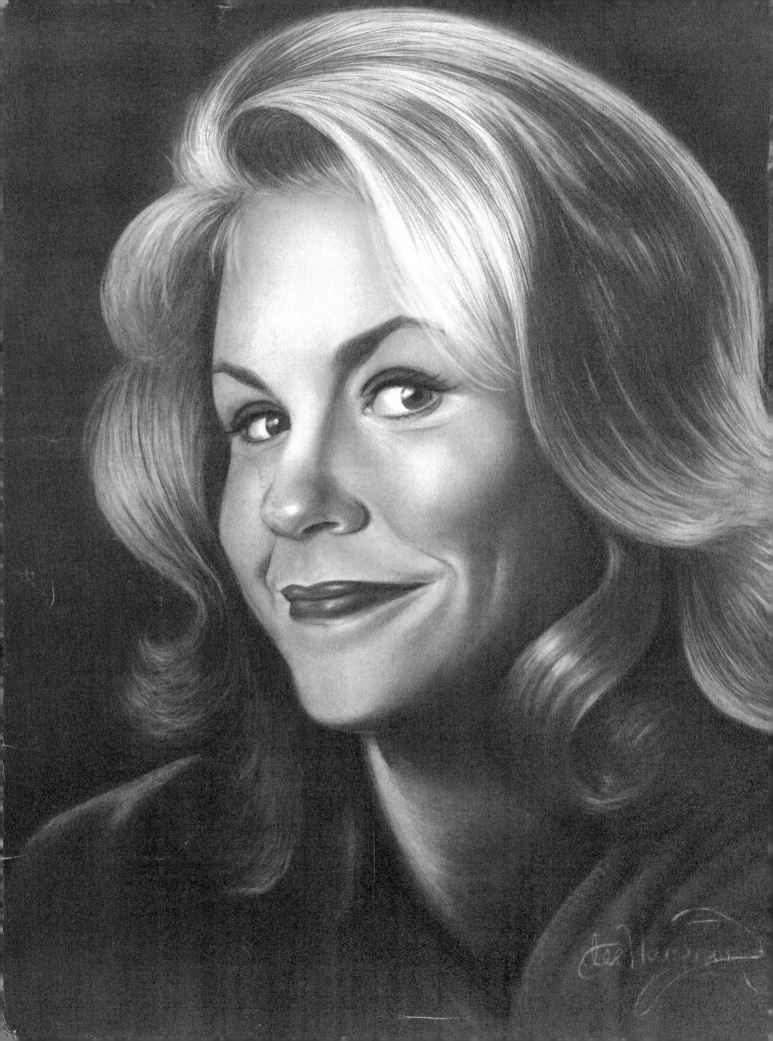

how to draw
LIFELIKE PORTRAITS
from PHOTOGRAPHS
REVISED EDITION

20 step-by-step demonstrations
LEE HAMMOND

NORTH LIGHT BOOKS
CINCINNATI, OHIO
www.artistsnetwork.com

ON PAGE 2

ELIZABETH MONTGOMERY
Graphite on smooth bristol
17" × 14" (43 × 36cm)

**LEE
HAMMOND**
Author, Illustrator

How to Draw Lifelike Portraits from Photographs, Revised Edition. Copyright © 2010 by Lee Hammond. Printed and bound in the United States of America. All rights reserved. No part of this book may be reproduced in any form or by any electronic or mechanical means including information storage and retrieval systems without permission in writing from the publisher, except by a reviewer who may quote brief passages in a review. Published by North Light Books, an imprint of F+W Media, Inc., 4700 East Galbraith Road, Cincinnati, Ohio, 45236. (800) 289-0963. Revised Edition.

Other fine North Light Books are available from your favorite bookstore, art supply store or online supplier. Visit our website at www.fwmedia.com.

14 13 12 11 10 5 4 3 2 1

Distributed In Canada By Fraser Direct
100 Armstrong Avenue
Georgetown, ON, Canada L7G 5S4
Tel: (905) 877-4411

Distributed in the U.K. and Europe by F+W Media International
Brunel House, Newton Abbot, Devon, TQ12 4PU, England
Tel: (+44) 1626 323200, Fax: (+44) 1626 323319
Email: postmaster@davidandcharles.co.uk

Distributed in Australia by Capricorn Link
P.O. Box 704, S. Windsor NSW, 2756 Australia
Tel: (02) 4577-3555

Library of Congress Cataloging-in-Publication Data

Hammond, Lee
 How to draw lifelike portraits from photographs / Lee Hammond.
-- Rev. ed.
 p. cm.
 Includes index.
 ISBN-13: 978-1-60061-970-0 (pbk. : alk. paper)
 1. Portrait drawing--Technique. 2. Pencil drawing--Technique. 3. Drawing from photographs. I. Title.
 NC773.H28 2010
 743.4'2--dc22 2010027163

Edited by Kathy Kipp and Holly Davis
Designed by Wendy Dunning
Production coordinated by Mark Griffin

ABOUT THE AUTHOR

Lee Hammond has been a professional illustrator and art instructor for more than thirty years. She has been an author for North Light Books since 1994 and has published more than twenty titles.

She is a certified Police Composite Artist and is on call for the Kansas City Metro area police departments as well as TV's "America's Most Wanted."

She has illustrated many of the NASCAR drivers, selling prints on QVC and NASCAR.com, and on her website, www. LeeHammond.com. Many of her art creations can be purchased from her online art gallery. She continues to add new art on a regular basis.

Lee's passion is and always will be teaching, and she currently teaches workshops full time nationally and internationally. She divides her time between Kansas City and Naples, Florida.

METRIC CONVERSION CHART

To convert	to	multiply by
Inches	Centimeters	2.54
Centimeters	Inches	0.4
Feet	Centimeters	30.5
Centimeters	Feet	0.03
Yards	Meters	0.9
Meters	Yards	1.1

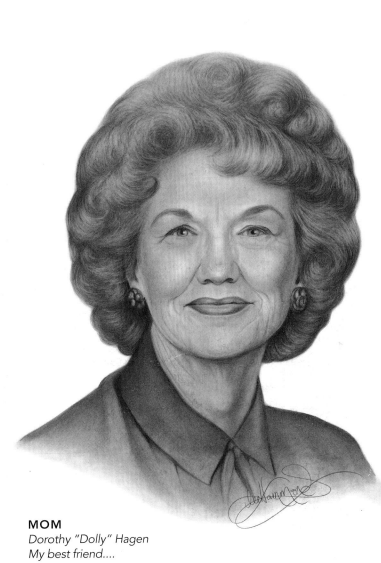

DAD
In memory of William D. Hagen Sr.
I will always be able to "hear" you....

Graphite on smooth bristol
14" × 11" (36 × 28cm)

MOM
Dorothy "Dolly" Hagen
My best friend....

Graphite on smooth bristol
17" × 14" (43 × 36cm)

DEDICATION

This book is dedicated to my parents. I thank them for giving to me the very best of them. I acquired my creativity and patience from my Mom and my work ethic and business acumen from my Dad. It was a combination of traits that helped make me who I am today.

Acknowledgments

It is an author's dream come true to have a book so successful that, fifteen years later, you can do it over again! *How to Draw Lifelike Portraits from Photographs* was my very first book. North Light Books has now given me the opportunity to recreate it, making it even better than it was before. I hope you will love this new edition as much as I do.

Writing a book is a daunting task, and without the support of the people around you, it would easily border on impossible. I have been blessed with the best friends and students in the world, and their undying support in all that I do is amazing to me. They are always my biggest cheerleaders whenever a new project comes my way.

I also have a family that has never once complained about my workaholic tendencies, and I know that it hasn't been easy. "Thank you" doesn't even come close to covering what I should say to all of them! I hope I have always been as supportive of them and their dreams as they have been of mine.

I want to give a special thank you to my friend Kristen Jaloszynski, who was kind enough to share some of her personal photographs for me to use in this book. She is an eye doctor who unselfishly travels all over the world providing free health care to people in need. Some of the artwork in this book is a reflection of the people she cares for. Thank you, Kristen, for giving so much of yourself for so many. You are awesome, admired and greatly appreciated!

My overwhelming thanks also goes to everyone at North Light Books, particularly Kathy Kipp, who was my very first editor. She has been such a huge support and wonderful friend. She is my editor again for this edition, and I know we will have many more books and years together!

Table of Contents

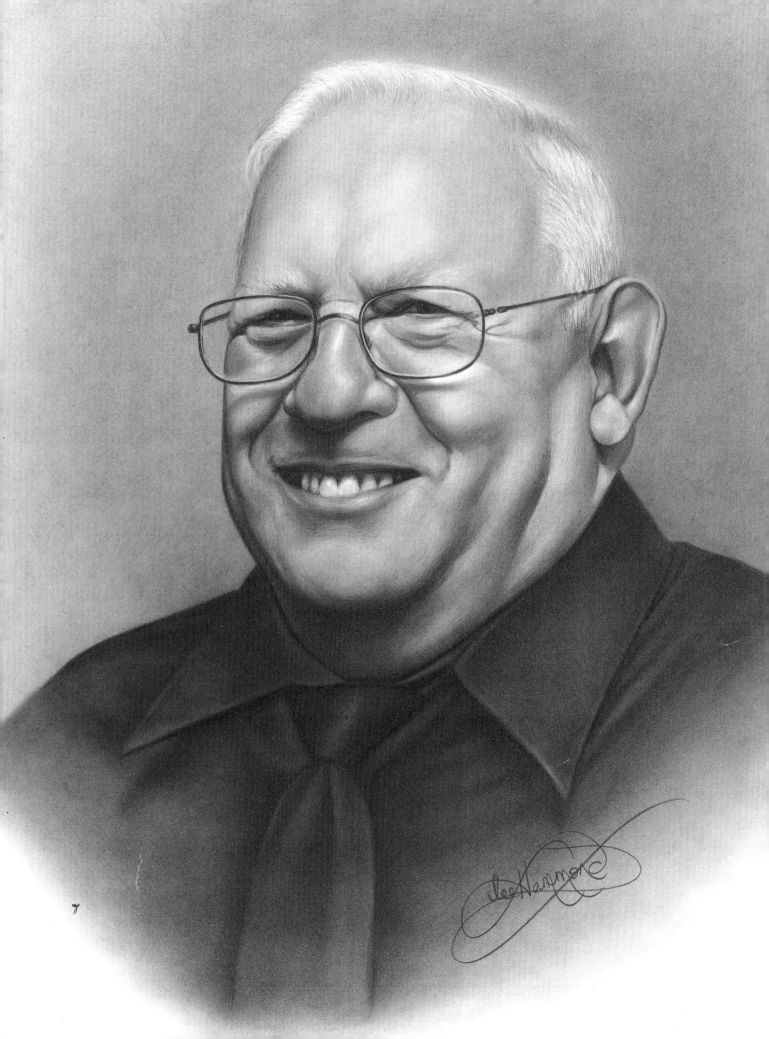

1 You Can Do It! Here's Proof

It is hard to believe that it has been fifteen years since my first book was published. It was exciting back then to have my methods published, introducing the "Hammond Blended Pencil Technique" to the world. Believe it or not, it was not that well received back then. No one drew like me, so it was not familiar.

But what a difference it made in the art field! Now, when you think of pencil drawing, it is my technique that most people think of. It changed the way people draw.

While thousands of people have learned this technique and have flourished in their art careers due to this book, I have grown because of it as well. I think you will see a change in my work over the past fifteen years. My drawings have become much more exact and polished. I am a perfect example of what I have been teaching all these years: it is practice that is the key to learning. Look at what it has done for me—it can do it for you too!

Like most artists, I have been drawing since childhood. I followed the same artistic steps as every child, from stick people to exaggerated features of my family and friends. As I progressed in age, my attempts at drawing became more of a challenge since I was no longer satisfied with the "normal" progression of my renderings. I wanted to draw like my grown-up sister, who is an exceptionally gifted artist to this day. School projects seemed too general for me, and my instructors insistence on creative expression, impressionism or abstraction, although interesting to me as concepts, did not suit my natural artistic desire. That need was not met through the many years of schooling, art classes and workshops that I put myself through. So began the long, hard process of teaching myself.

Over the years, my artwork finally began to take the shape that I wanted it to, and I began to sell my work and to teach the very technique that I had developed. This book comprises the information I have accumulated through years of teaching and being taught. Many of the issues addressed here are based on actual questions raised by my students. It is a book that can instruct the self-learner or one that can be used in a classroom situation. This is the very book that I wish had been available to me when I was learning!

To get the most out of it, take this book step-by-step in the order in which it is presented, whether you are a beginner or advanced. I promise you will see results not only in the way you draw, but also in the way you see things. Practice, and lots of it, will be the key to your success. The lessons within, combined with your desire, will lead you to some of the best drawing you have ever done.

IN MEMORY OF LANNY ARNETT
My best bud for 27 years!
Somehow, it just isn't as much fun without you...

Graphite on smooth bristol • 17" × 14" (43 × 36cm)

Before

PRINCESS DIANA
Artwork by Briauna Jarvis, age 17.
First attempt at portrait drawing.

Let's look at some drawings I have collected from my students. In each set, the first example shows how the student was drawing before taking my classes and is typical of how most people draw at the beginning stages of their artistic development.

When looking at a student's beginning work, you'll notice certain characteristics that are common to everyone's beginning attempts. First, the student takes a simplistic approach when drawing the face and the hair. There is usually an extreme overuse of hard lines without smooth transitions in tone. This creates a harsh, outlined look. Second, there's an overall lack of understanding of the facial features.

The sketch above is a first attempt at portrait drawing by a 17-year-old student who had recently joined my group. During one of my travels, I had taken a photo in a wax museum of a likeness of Princess Diana. The likeness of the wax figure was so realistic it was just like looking at her, and the photo I took of it became a perfect photo from which to draw Diana's likeness.

My student did the best she could the first time without any help from me. It is a typical outcome produced by a new student with no previous portrait drawing experience.

You can see that the likeness is not quite there. A portrait should never look just "similar" to someone; it must be a total reflection of them. Getting close just doesn't cut it in portraiture!

You can see how harshly some of the areas are drawn. Beginners always have a tendency to over-draw with hard and very distinct lines. The shadow areas are too harsh and look solidly filled in, as if they were a separate object on top of the skin. While the student did make a good attempt at blending, it still looks a bit irregular and choppy in places. Most beginners tend to blend randomly just to try to smooth it out, but blending is still "drawing" and it must help create shape.

The hair is also a good attempt, but it lacks depth and the look of volume and layers. Hair takes time to learn, and here, she is still at the beginning stages of applying the pencil. It needed a lot more work.

After

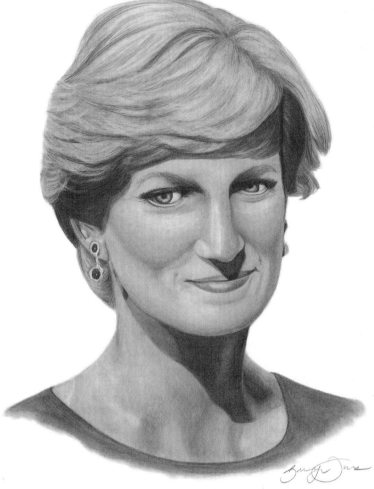

PRINCESS DIANA
Artwork by Briauna Jarvis. A much improved drawing!

Student Testimonial
"I have always wanted to draw people. I didn't think I could do a very good job, and I wasn't happy at all with my first drawing. Lee made me do it all on my own, and it was really frustrating! After studying her book and having her show me some things, I was really surprised at how much better I did the second time. I learned how to make the blending more smooth. I also learned how to "see into" shadows, not making them so dark and solid. I also learned that drawing hair takes the longest!"

—Briauna Jarvis

The second example shows how, after studying my book and using some of my tricks and techniques, the student created a much better likeness. The drawing looks more controlled and accurate. Now there's no doubt whose portrait this is.

I showed my student how to use a projector to achieve her basic line drawing rather than free-handing it. Because of this, her likeness is much more accurate. The graphing technique explained in this book produces the same outcome. It is merely a method for placing the drawing on the page with a good degree of accuracy before you start the rendering phase. It is the rendering that turns the piece into true art.

Her blending is much more smooth and even this time. Because of the way it has been applied, it helps create the roundness and form of Diana's face. Now the blending looks natural, not just like dirty smudging.

The shadows have really improved. They no longer look solid, and you can actually see the form of the anatomy through them. A shadow is not a separate form. It is just where the shapes you are drawing are receiving less light. The shape still has to be seen "within" the shadow.

Everything here looks better than before. Even her signature looks more artistic than the first one! Believe it or not, your signature is an important aspect of the drawing. It helps make your piece look more professional.

Before

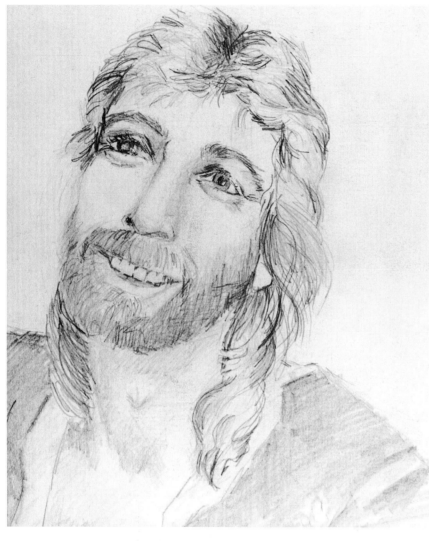

Artwork by Angie Wolf
(portrait of Kenny Loggins, first attempt)

Here is another example of what a student did before and after my classes. Both drawings were created from the same photo reference. She brought the drawing above with her on the first day of class so I could see what she had been doing in her college classes. Again, you can see the simplistic approach that was taken. It has a "sketchy" appearance, but the student wanted a more polished look to her work.

Notice the rough use of line and the lack of accuracy in the likeness. The features seem poorly proportioned and incorrectly positioned.

After

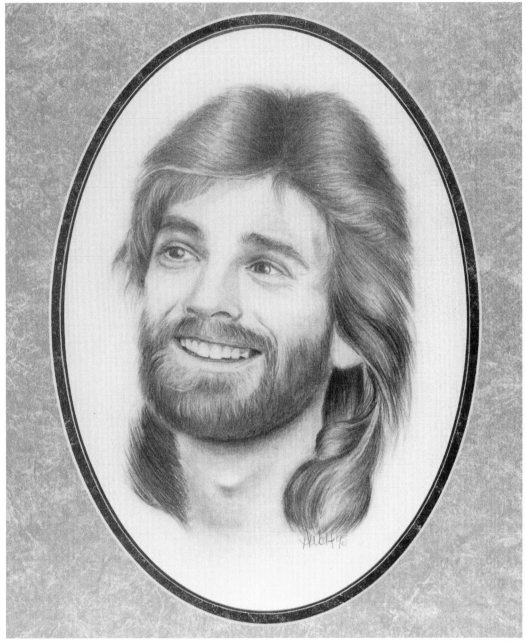

KENNY LOGGINS
Artwork by Angie Wolf
14" × 11" (36 × 28cm)

Once again, the second drawing shows what the student was able to achieve after studying the lessons in this book. The likeness of Kenny Loggins is much more accurate, and the blending and shading is more realistic in appearance. The features are correctly pro-portioned and positioned. The hair and beard now have depth and volume, plus a softness and shine that is not seen in the first sketchy attempt.

I love the way the portrait has been double matted. This helps give the drawing a finished, professional look.

2 Blending: The Key to Realistic Portraits

Drawing is a very personal thing. It's an accumulation of information, education and experiences, all combined with our own special, unique personalities. Because of this, no one style of art or any particular drawing technique can be considered right or wrong, but merely different.

Where some styles and subject matter lend themselves to impressionistic, bold statements and applications, the drawings in this book will concentrate on a gradual, smoothly blended appearance. I feel this particular style of drawing best replicates the smooth, subtle characteristics of skin, thus providing us with realism in our portrait work.

The key to this style of drawing can be summed up in two words: gradual blending. This means a smooth application of tones, from very dark to extremely light, with a very gradual blend in between. It should be so gradual that you cannot see where one tone ends and another begins.

We will be focusing on three major concepts throughout this book, concepts that will apply to everything you draw: shapes, lights and darks. Training your eye to see these things correctly takes time, so we will approach each one singly and slowly. Once you can see things as just "shapes," your accuracy will automatically improve.

But the most important goal is blending. If applied accurately, blending will make any shape you draw appear realistic. The questions of where and how shading should be placed and blended will be explained and demonstrated thoroughly, and the mystery behind the "Hammond Blended Pencil Technique" will be revealed!

PORTRAIT OF THE AUTHOR
Graphite on smooth bristol • 17" × 14" (43 × 36cm)

Learning to blend with graphite

The key to the blended pencil technique is the gentle blending of tone from dark to light. There should be no choppiness or interruption of tone. You should not be able to see where one tone ends and another begins.

The smoothness is achieved by applying your pencil lines softly, and always in the same direction. Build your tones slowly and evenly. Lighten your touch gradually as you make the transition into your lighter areas. Smooth everything out with a blending tortillon, moving in the same direction you used to place your pencil tone, beginning with the darks and blending out to the light.

Always use the tortillon at an angle. Using the tip will cause the end to push in and become blunt. If this should happen, you can repair it by sticking the end of a straightened paper clip inside of it and pushing the tip back out.

Do not throw your tortillons away as they become dirty! Save them, and divide them into groups according to how much graphite they have on them. A very black tortillon will be just what you need to blend out a dark area later, like a dark head of hair or a background.

Always use a fresh tortillon for the light areas, and don't be tempted to use the same ones over and over again to conserve. They are inexpensive; I buy them by the gross so I never have to hunt for a clean one when I need it.

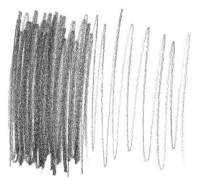

Incorrect Blending
Notice the obvious pencil lines that weren't blended out. The tones are choppy and rough, not even and gradual.

Always hold the tortillon at an angle to keep from flattening out the tip.

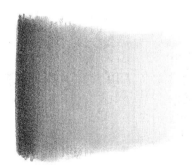

Correct Blending
This example is smooth and even. It was achieved by applying the pencil lines very close together.

MATERIALS NEEDED FOR SMOOTH BLENDING

- **Smooth bristol board or sheets, two-ply or heavier**
 This paper is very smooth (plate finish) and can withstand the rubbing associated with this technique.

- **.5mm mechanical pencil with 2B lead** The brand of pencil you buy is not important, since they all use the same lead. Although they all come with an HB lead, replace it with a 2B.

- **Blending tortillons**
 These are spiral-wound cones of paper. They are not the same as harder, pencil-shaped stumps that are pointed at both ends. Tortillons are better for the blending technique. Buy both large and small.

- **Horsehair drafting brush** These brushes will keep you from ruining your work by brushing away erasings with your hand and smearing your pencil work. They will also keep you from spitting on your work while blowing the erasings away.

- **Kneaded eraser** These erasers resemble modeling clay and are essential to this type of drawing. They gently "lift" highlights without ruining the surface of the paper.

- **Pink Pearl eraser**
 These erasers are meant for erasing large areas and lines. They are soft and nonabrasive, and will not damage your paper.

- **Workable spray fixative** This is used to seal and protect your finished artwork. It can also be used to "fix" an area of your drawing so it can be darkened by building up layers of tone. The term "workable" means you can still work on your drawing after it has been sprayed.

- **Drawing board** It is important to tilt your work toward you as you draw to prevent distortion from working flat. A board with a clip to secure your paper and reference photo will work best.

- **Portfolio case** This is a large, flat carrying case to hold your projects, papers and drawing board. This is not to be confused with a presentation case that has acetate pages inside.

- **Art or tackle box** These are essential for carrying all of your drawing supplies.

- **Ruler** You'll need a ruler for graphing and measuring features.

- **Templates (stencil guides), both circle and ellipse** These are used for accurately drawing the irises and pupils of the eyes.

The five elements of shading

To render something realistically, the artist must fully understand the lighting on the subject and the five elements of shading. The form of any object is created by the correct placement of lights and darks, the five elements of shading, and the gentle blending of the tones together.

Every tone on the object you are drawing should be compared to black or white. But how do you know how dark to draw something? Let's look at the value scale and sphere on the facing page. Using a simple five-box scale of values can help you decide on the depth of tone. Each one of the tones on the scale represents one of the five elements of shading. For example, tone number three on the value scale—medium gray—corresponds to shading element number three on the sphere: the halftone (halfway between white and black). Here are the five elements of shading that you can see on the sphere:

1 **Cast Shadow.** This is your darkest dark and should be made as close to black as possible, as seen in box number one on your scale. This is the shadow that the object you are drawing is "casting" on the surface on which it lies. The shadow is the darkest where the object and the surface touch. It then lightens gradually as it gets farther away from the object.

2 **Shadow Edge.** This is dark gray and corresponds with number two on your value scale. This is not the edge of the object; it is where the object is receding from the light, and it is on the opposite side of the light source.

3 **Halftone.** This is medium gray or number three on your value scale. This is the true color of the object without the effects of direct light or shadow. It is neither light nor dark, so it is called a halftone.

4 **Reflected light.** This is the small light edge seen around the object, particularly between the cast shadow and the shadow edge. This is really the light bouncing back from the surrounding surfaces. It is the light that makes the object appear round and solid and tells us that there is a back side to it. Reflected light is never bright white! It is closer to a halftone, like box number four on the value scale.

5 **Full Light.** This is where the light hits the object full strength. Full light should be represented by the white of the paper. The gray areas should be blended into this area very carefully so no hard edges are created.

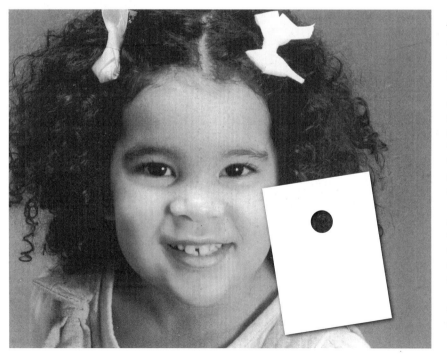

How to Analyze Tones

To help you analyze tones and how they compare to black or white, use this little trick: Take two small pieces of pure white paper and punch a single hole in each one. Place the hole of one of them over the area of the photo you are analyzing. Look and see how the color, or tone, of that area looks inside the small hole. Then compare it to the white of the paper around it to see how dark it really is. It usually appears much darker than you thought.

Take the other piece and place it over the same spot in your drawing. Compare the two, and see if you have correctly drawn the depth of tone. Usually, it has been drawn too light. The most famous phrase I use in my classes is "Get it darker!" Not going dark enough will cause your drawing to lack depth.

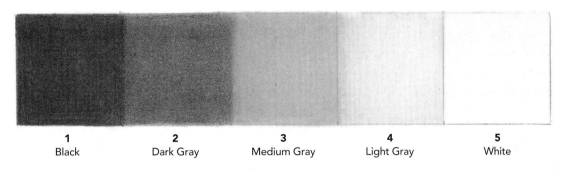

1 Black	**2** Dark Gray	**3** Medium Gray	**4** Light Gray	**5** White

Notice how the five elements of shading on this sphere correspond to the five tonal values on the scale above. The light is coming from the front, a little off to the right.

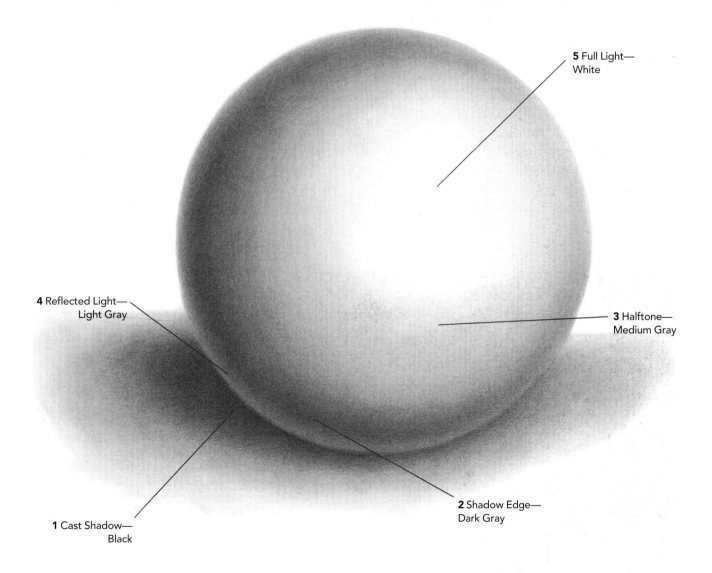

5 Full Light—
White

3 Halftone—
Medium Gray

4 Reflected Light—
Light Gray

2 Shadow Edge—
Dark Gray

1 Cast Shadow—
Black

Correct blending techniques

Before you begin drawing actual objects, you should get a good feel for your tools and materials. I recommend that you first draw some blended-tone swatches, as shown on page 16, to help you learn to control your blending. Start with your darkest tone on one side and gradually lighten the tone as you continue to the other side. Do as many as you need to until you feel proficient at it.

Once you begin to draw actual objects, such as the cylinder shown below, use the following guidelines to help you.

1 **Soft edge.** This is where the object gently curves and creates a shadow edge. It is not harsh, but a gradual change of tone.

2 **Hard edge.** This is where two surfaces touch or overlap, creating a harder-edged, more defined appearance. I do not mean outlined! Be sure to let the difference in tones create the edge.

3 **Application of tone.** Always apply your tones, whether it be with your pencil or tortillon, with the contours of the object. Follow the curves of the object, with the shading parallel to the edges so you can blend into the edge, and out toward the light. It is impossible to control blending if you are cross blending and not following the natural edges and curves.

4 **Contrast.** Don't be afraid of good solid contrasts of tone. Always compare everything to black or white. Use your five-box value scale to see where the gray tones fit in. Squinting your eyes while looking at your subject matter obscures details and helps you see the contrasts better.

The sphere, the egg and the cylinder are all important shapes to understand if you want to draw portraits. If you can master the five elements of shading on these simple objects first, drawing the human face will be much easier.

Additional Helpful Hints

• Uneven tone can be corrected by forming a point with your kneaded eraser, then drawing in reverse. Use a light touch and gently remove any areas that stand out as darker than others. Light spots can be filled in lightly with your pencil.

• Areas that need to be extremely dark can be sprayed with fixative and the darks built up in layers. Be sure that any erasing that needs to be done is finished before spraying.

• Use your kneaded eraser to crisp up edges and remove any overblending.

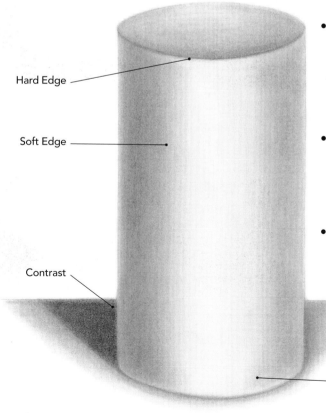

Hard Edge

Soft Edge

Contrast

Tone

Three basic steps of rendering

All rendering requires three basic steps. First is an accurate line drawing or outline of your subject matter. An outline is merely the outside shape, whereas a line drawing includes the interior details. It is the foundation of your drawing and acts as a guide for placing tones. Second is the identification of lights and darks and placing them in like puzzle pieces, much like a map. And third is the blending of all your tones together, smoothly and gradually. As you study and practice the shapes below, refer back to the Five Elements of Shading on pages 18-19.

I suggest that you draw these shapes at least three times each, with the light source coming from a different direction each time (top, left side, right side). This may seem repetitious, but practice is the key to successful portrait drawing.

1 ACCURATE LINE DRAWING
Once the object's shape has been drawn accurately, you must identify the light source. The area on the object where the light shines the brightest can be lightly outlined. You'll erase those lines later. Since all shadows are opposite the light source, you can also place your cast shadow. You now have your lightest light and your darkest dark.

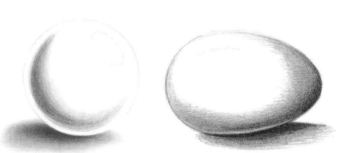

2 PLACEMENT OF TONES
Placement of the shadow edge must be done carefully. Pencil lines should be applied smoothly going "with" the shape of the object. Make sure to leave room for the reflected light. Keep it low where it belongs; this is a shadow; it cannot be up in the light.

3 BLENDING
Blend with your tortillons to create your halftones. Blend "with" the object's shape from dark to light. Make sure it is a smooth blend. Allow the tone to create the edge of the object, and remove any outline that may be showing. Anything with an outline around it appears flat. Correct any unevenness in your blending. Light spots can be gently filled in to hide them. Dark spots can be gently lifted with a pointy piece of your kneaded eraser.

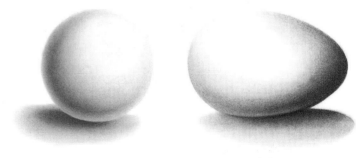

The puzzle piece theory: A guide to seeing shapes

Before you begin any type of blending on your artwork, it is very important to give yourself a firm foundation from which to build. This is achieved by giving yourself an outline and accurate line drawing first.

The easiest and most educational way to draw a portrait from a photo is by using a grid. A grid is simply a tool that divides your photo into smaller, workable boxes. To help you understand how a grid works, I have developed a graphing exercise that's fun to do, like a puzzle.

At right is a series of numbered boxes that contain black and white nonsense shapes. By drawing these shapes in the corresponding numbered boxes on the empty grid on the facing page, you will prove to yourself that you can draw. This exercise teaches you to see just shapes and shapes alone. Do not try to figure out what you are drawing. As soon as we become aware of what the subject matter is, we start to draw from our memories instead of from what is right in front of us.

No matter what we are drawing, we should learn to see the object as many individual shapes, all interlocking like a puzzle. This can be referred to as "mapping." If one of the shapes we are drawing does not lead us to the next one, fitting together with it, we know that our drawing is inaccurate.

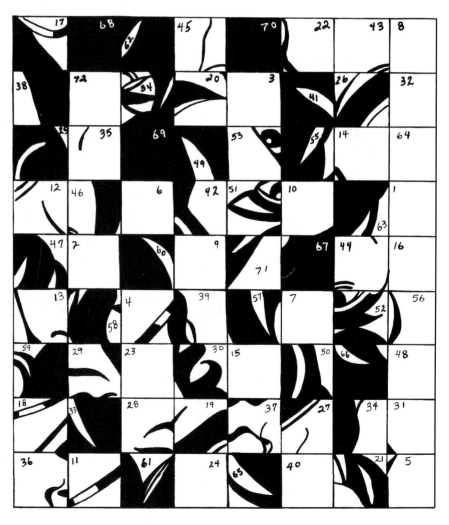

Once these nonsense shapes are drawn in their correct positions on the graph at right, the subject will be revealed.

1	2	3	4	5	6	7	8
9	10	11	12	13	14	15	16
17	18	19	20	21	22	23	24
25	26	27	28	29	30	31	32
33	34	35	36	37	38	39	40
41	42	43	44	45	46	47	48
49	50	51	52	53	54	55	56
57	58	59	60	61	62	63	64
65	66	67	68	69	70	71	72

Make a photocopy of the empty grid above, then draw in the
nonsense shapes exactly as you see them in the puzzle at left. Be
sure to draw each shape in its corresponding numbered box.

Practice the five elements of shading

Now that you have some practice drawing the sphere, you have the information needed to draw anything with more realism. But it is important to allow this information to soak in a little before you jump ahead too quickly. The five elements of shading need to become second nature to you, and that only comes from practice. By nature, people are impatient, and it is perfectly normal to want to learn everything in one day, becoming a professional the next. But it simply does not work that way. I find that the most successful students are the ones who stay in the book the longest and resist the urge to jump into a complicated project before they are ready.

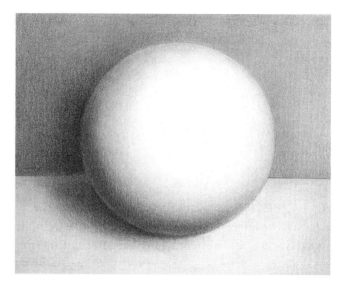

These examples show how to practice the sphere without getting tired of it. Try creating spheres with different light sources like the one above right. By drawing a border around it, you can learn to control your blending in a small area. Placing a dark background around the sphere completely changes the look of it. But the five elements of shading are still clearly seen.

The example at right adds a little fun to the project. Notice how the five elements of shading are also seen in each of the fingers. It is the foundation for everything, so learn it by heart before you forge ahead!

Honing your blending skill

Sometimes it's better to practice something other than a face until you become extremely familiar with facial anatomy. Trying to capture a person's likeness can be frustrating at first, and the learning process then becomes lost. Before you can create a believable portrait, you must hone your blending skills. The rendering on the next page is an example of drawing something "familiar" while not overwhelming yourself with a person's likeness.

If you look at this drawing, it is easy to see where the five elements of shading have been used. It is a great example of *hard edges* and *soft edges*. Let me explain the difference. (Memorize this, because this is extremely important!)

A *soft edge* occurs anytime you have a surface that is rounded and curved. The soft edge is found where the object had protruded, and is then curving backwards. On the sphere, it would also be called the *shadow edge*. Study this example, and you can see how all of the soft

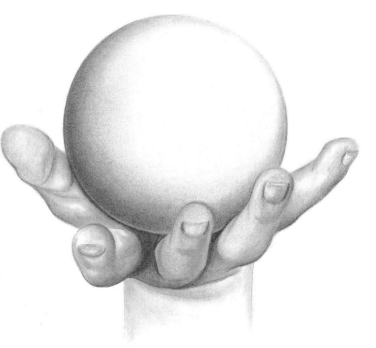

edges make the thumb and fingers look rounded, like cylinders.

A *hard edge* is found any time you have two surfaces touching, or overlapping. You can see them in this example where the fingers overlap the hand.

To create a hard edge, it is necessary to draw a hard line. This creates a definite separation between two separate surfaces; however, outlining is never used in realism, for there are no "outlines" in nature. Nothing in your drawing should look like an outline. So, you must adjust the look of the hard line with shading.

To do this, you must analyze your reference and look on either side of the line you have drawn. You must then decide which surface is darker and shade out from the line you drew into the darker side. Any time a line is drawn, the darkness of that line must be assigned a surface to belong to.

Let me explain a bit further. Look at the area where the fingers overlap the palm. When I drew the lines to create the fingers, I then shaded out from those lines into the surface areas of the fingers. This is because the lighting makes the palm of the hand lighter than the edges of the fingers, so the darkness of the lines belongs to the fingers, not the hand. This can be a challenge for a beginning artist, because logic would make you think that the darkness would be underneath the fingers instead. But, since the fingers are elevated and there is space between the fingers and the hand, the lighting is altered. Study the edges of the fingers. The lighting changes as it goes from the tip to the base. On the tip, the edge of the fingers appears as "dark over light." But continue inward, and the edge changes to "light over dark," due to the cast shadow on the palm. Look at the areas of the fingers closest to the inside of the hand. You can see reflected light along the edge of the finger where the palm of the hand is darker. It is so important to study your reference for subtle issues like this. These are the five elements of shading hard at work!

Study the rest of the drawing and you can see these principles everywhere. Study each area of overlap and discover the hard edges and soft edges and areas of reflected light. If you feel ambitious and want to get in some very good practice, draw this yourself. It will be a good lesson on everything we have learned so far.

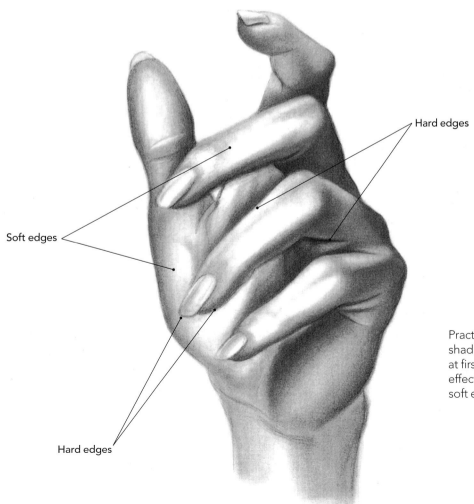

Hard edges

Soft edges

Hard edges

Practice creating the five elements of shading in something other than a face at first. This example clearly shows the effects of lighting and how it creates soft edges and hard edges.

Putting it all together in a portrait

In this portrait you can clearly see how the five elements of shading apply to the human face. Note how the roundness of the face is accentuated by the shading and the use of shadow edges and reflected light. The light source in this case is coming from the front.

The simple shapes we have studied can also be seen. The egg shape can be seen in the overall shape of the human head. The sphere can be seen in the facial features such as the cheeks and the nose. And the cylinder can be seen in the shape of the neck.

CAYLA LEE
Graphite on smooth bristol • 17" × 14" (43 × 36cm)

Important Points to Remember

1 Keep your blending extremely smooth and gradual with no choppiness.

2 Always use a tortillon at an angle to protect the tip.

3 Use your five-box value scale to judge your tones. Compare everything to black or white.

4 Use your papers with the hole punched in them as value finders to compare your tones to those of your reference photo.

5 Keep in mind the five elements of shading and their placement.

6 Always begin your work with an accurate line drawing.

7 Anything with an outline around it will appear flat and unrealistic.

8 Look for the basic shapes: the sphere, the egg and the cylinder.

9 See your shapes as interlocking puzzle pieces.

10 Practice is the key to success.

11 Repetition is the key to learning.

12 Repetition is the key to learning.

13 Practice!

14 Practice!

15 Practice!

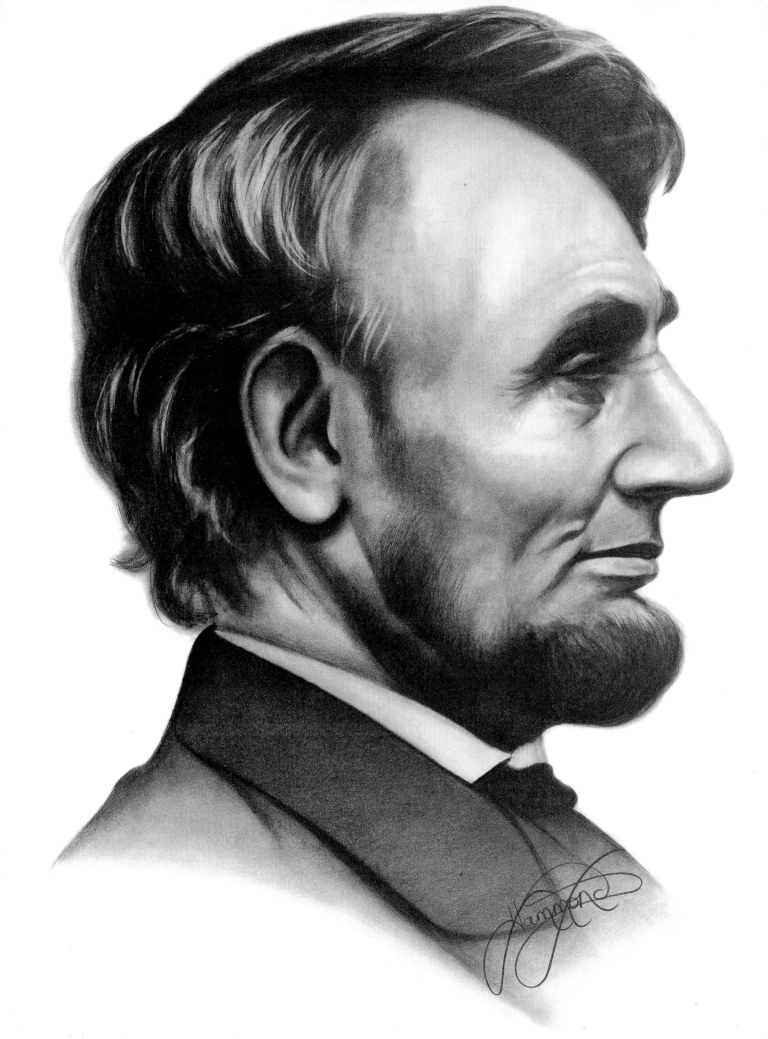

3 Drawing the Nose

Why should we begin with the nose? Although it may seem unusual to begin there, it really is the most logical next step. Because of the nose's similarities to the sphere, it is an excellent way to learn the elements of shading and how they apply to all the facial features. Since blending is the key element to this entire style of drawing, starting with the nose gives you the opportunity to practice the shading and blending principles you learned in Chapter 2.

The nose is not one single shape like the sphere, but is a continuation of the face, a projection. It is similar to the sphere in its roundness and how it reflects light.

The nose is also important to the overall size and scale of all of the other facial features. It is in direct proportion to the size and shape of the eyes, mouth and ears. A nose that is drawn inaccurately will affect the total outcome of the portrait and ruin the likeness. By drawing the nose, you will learn to gently connect everything together on the face, seeing the face as a whole, with everything correctly related and blended together.

You will study the proportions of the head, the placement of the other features, and achieving a likeness later, after you have fully explored and conquered the blending technique.

If you can draw a really good nose, you are on your way to some very good portrait drawing!

ABRAHAM LINCOLN
Graphite on two-ply bristol • 12" × 9" (30 × 23cm)

Start with a sphere

Drawing a nose is easy if you first break it down into its component shapes. The drawings in the middle show how the sphere shape can be seen in the shape of the nose. But unlike the sphere, which is one continuous shape, the nose has multiple protrusions, or "planes." Each sphere and plane contains its own set of at least four of the five elements of shading.

First, you must identify where your light source is in order to place your shadows and tones correctly. On the illustration of the nose below, the full light area is on the front of the nose, with the shadow areas on the opposite side. Every photo reference you use will have its own light source, so study it carefully before you begin to draw.

While studying the examples, refer to your five-box value scale to see how dark the tones of the nose are. On every nose, the darkest area will be inside the nostril. This is a cast shadow, since the front of the nose is blocking the light. Like all cast shadows, it becomes lighter as it comes toward the light.

The shadow edges can be seen on the side of the "ball" of the nose, under the nose, between the nostrils and around the side of the nose where it connects to the face.

Reflected light, which is important to show roundness, can be seen clearly around the edge of the nostrils. Any surface that has a "lip" or rim will reflect light. There is also more subtle reflected light anywhere you find a shadow edge, since it is this light that separates shadow edges from cast shadows.

The nose has many of the simple shapes we practiced in Chapter 2. If you look carefully, you will see egg shapes and spheres within the overall shape of the nose. Gradual blending of tones gives the smooth appearance of skin.

This nose can easily be seen as three individual spheres.

Full Light Area

Shadow Edges

Halftone Area

Reflected Light

Cast Shadows

The five elements of shading can be seen on every area of the nose.

Use blending to give form

Never use hard lines to draw the shape of the nose. This will make your drawing seem cartoon-like. Remember that anything with an outline goes "flat."

The nose has many surfaces or planes. By sketching a chiseled look, you can see how these planes make up the nose, and how these shapes angle into the face.

The nose is a continuation of the face; it is not separate and sitting on top of it. The use of smooth blending from dark to light will give the illusion of depth and form, which is necessary to achieve realism.

Your light sources may vary drastically from photo to photo; some photos will be brightly lit and others will be dark and shadowy. The light source can make a huge difference in your contrasts and the way you must draw them. The darker the shadows, the brighter the full light area will appear. A soft, diffused light source will make the difference in tones less obvious.

The drawing at far right shows some extremes in contrasts, due not only to the light source but also to the darker skin tones. Don't be afraid to achieve good solid darks if that is what you photo reference calls for.

When drawing the nose, include the side of the face as a foundation from which to build the nose. Using the cast shadows on the surrounding areas will also help describe the nose's shape.

A chiseled nose, drawn with angled lines, shows the planes.

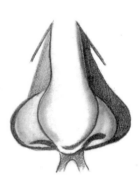

Never outline the nose—it will look like a cartoon.

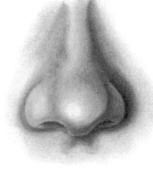

A blended nose gives the illusion of form.

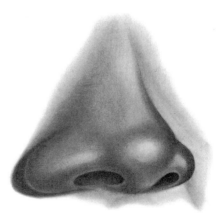

The nose in bright lighting has less contrast between the darker and lighter tones.

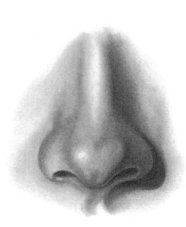

A nose in heavy shadow has more contrast.

Look for extremes in tones and contrasts.

Drawing the nose step by step

One of the keys to drawing a lifelike nose is to look for hard and soft edges. Soft edges are created by the roundness of the nose and are seen as shadow edges. Hard edges are seen in the nostril area because a hard edge is formed when two surfaces overlap. A hard edge is also seen where two surfaces "touch," such as where the nose meets the face. However, this edge is more subtle and lighter in tone.

Repetition and practice are the keys to learning how to draw, especially when you are teaching yourself.

Look through magazines for facial reference pictures and draw as many noses in as many different poses as you can find. Later in this chapter you will learn how to graph off these pictures to achieve an accurate line drawing. It will also be beneficial to draw from the illustrations in this book, since sometimes it is easier to study the blending when you "draw from a drawing" first.

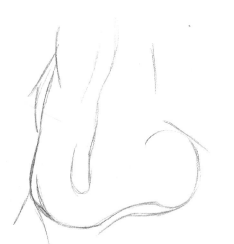

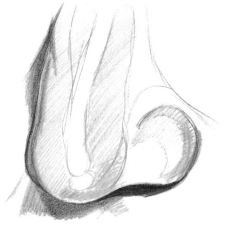

1 ACCURATE LINE DRAWING
Remember, before you can begin any blending, you must always start with an accurate line drawing. This stage is very important. No blending should be applied until your basic shapes are perfected. It is extremely difficult to correct the shape of a drawing once the blending process has been started.

First, look for the spheres and planes in the shape of the nose and lightly sketch the basic shape. Include guidelines for the highlighted areas.

2 PLACE THE TONES
When placing your tones, they should first be assigned a shape, much like that of a puzzle, with each tone connected to another. This goes for both light and dark areas. These "tone shapes" will give you a guideline for your blending and help maintain the shape of the nose. Your drawing at this stage will resemble a map.

3 BLEND
The blending stage should be done very carefully to keep your tones smooth. Be sure that your original puzzle piece shapes no longer show. Pull any highlight areas out with your kneaded eraser rather than drawing around them.

Practice drawing the nose

Here are some more opportunities to practice the principles that we have learned so far. Not only are the poses different in both examples, the lighting is too. Watch carefully for subtle changes in tone. Squinting your eyes as you look at drawings will make the tones more obvious in their contrasts, and things like reflected light will be easier to see. Try to imitate the tones as closely as possible. Refer to your five-box value scale for tonal comparisons if you need to.

When blending, use a fresh tortillon if yours are starting to get a little soiled. Going into a light area with a dark tortillon will not give you the soft results you want. Save the dark ones for use in dark areas of your artwork.

Fine tuning your artwork is the last stage. This is where you correct any errors or inconsistencies in your blending. Light areas that show up in your blend should be filled, and dark spots lightened with the kneaded eraser. Don't stop until you are satisfied with the appearance of your work.

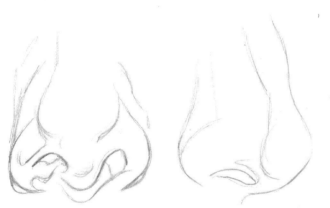

Accurate Line Drawing
This is the most important element of your artwork. Without accuracy at this stage, everything else will be incorrect.

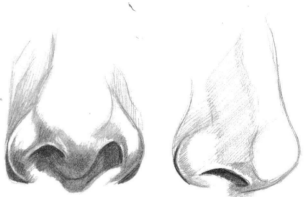

Placement of Tones
Assign all of your shapes a tone. Check your five-box value scale if you need to. Do you see how these shapes all interlock like a puzzle?

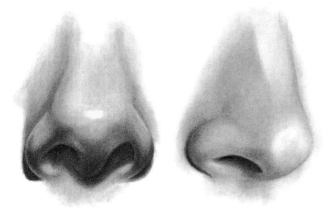

Blending
Blend the tones from dark to light, following the contours of the shapes. Keep your blending smooth and gradual.

How to graph a facial feature

Now that you are familiar with the Puzzle Piece Theory and the grid-box method of drawing shapes (see pages 22-23 if you need to review), you are ready to draw the nose by using a grid. Before you start, you will need to make a clear acetate overlay with a grid on it.

Purchase a tablet of clear acetate sheets at any art supply store. With a permanent, fine-point marker and a ruler or T-square, draw two large rectangles on the acetate. Divide one into 1-inch (25mm) squares, the other into ½-inch (13mm) squares. Be sure that your lines are very straight and parallel so your boxes will be perfectly square and equal in size.

Slip a photo or magazine picture under your acetate grid. Do you see how the image is divided into equal squares? Very lightly, draw another grid, in pencil, on your drawing paper. It should contain the same size and number of boxes necessary to capture the size of the photo you are working from. With these grids, you are now ready to create an accurate line drawing.

These grids will also help you draw from the illustrations in this book. Just place the grid over the one you want to work from. Use the 1-inch (25mm) grid for images that do not have a lot of detail and the ½-inch (13mm) grid for images that have many small details. (The smaller the box, the less room for error.)

You can also use your grid to enlarge or reduce your photo reference. To make something bigger, make the squares on your drawing paper larger than the ones on your grid. For instance, if your grid is ½-inch (13mm), placing 1-inch (25mm) squares on your paper will make your drawing twice as big as the photo. You can reduce by reversing the process. The shapes you are drawing will be the same, as they relate to the squares they are in.

A ½-inch (13mm) grid works well for highly detailed images.

A 1-inch (25mm) grid is fine for images with few details.

Graphing the nose

Graphing a photograph will help you see your subject as just "shapes." Study the photos below to see how the overall shapes of the nose, as well as the shadow shapes within, have been transferred into a line drawing. Using these photos as a guide, draw these noses for practice.

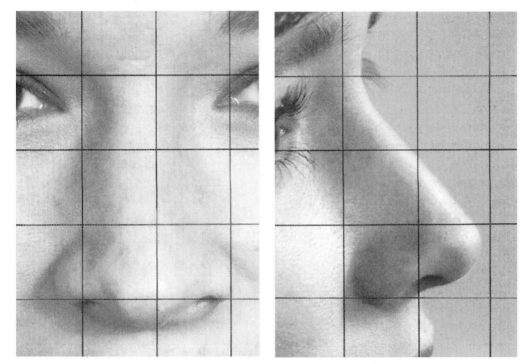

I recommend this grid size, although you can make a grid with any size boxes as long as the boxes are truly square (a T-square will help).

Remember to draw your grid lines very lightly on your drawing paper so they can be erased easily when your shapes are accurate. (These grids have been darkened in the book so you can see them more clearly.)

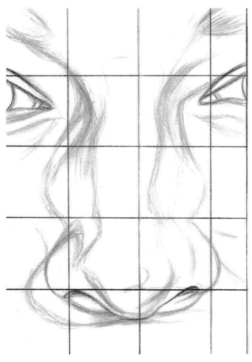
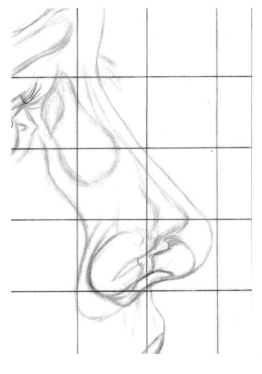

The rendering phase

Once you are happy with the accuracy of your line drawings using the grid system, start the rendering phase. Carefully erase the grid lines with a kneaded eraser. Be careful not to inadvertently erase your line drawing at the same time. When you have totally erased the grid, follow along to create drawings from the photo references on the previous page.

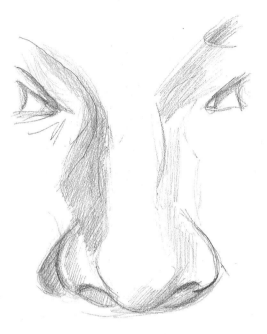

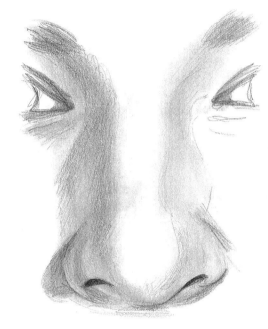

1 DEVELOP THE FORM
Begin to develop the form of the nose by adding the darkest shadow areas first with your pencil.

2 BLEND AND DEEPEN TONES
Gently blend the tones out with a tortillon to make the tones appear smooth. Deepen the tones inside the nostril area and deepen the tones of your drawing if the blending made them lighten too much. Blend again if needed.

3 LIFT OUT HIGHLIGHTS
Continue to add tone and blend until the tones have been accurately produced. Use a kneaded eraser to lift out highlight areas.

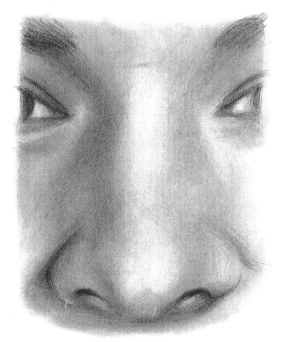

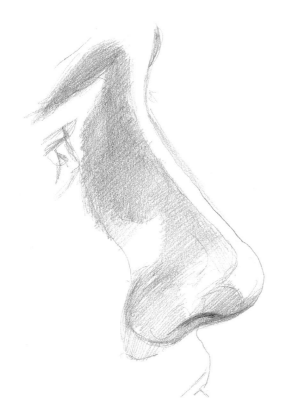

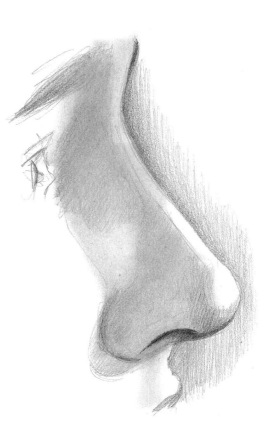

1 DEVELOP THE FORMS
Develop the form and tones of the nose with your pencil.

2 BLEND THE TONES
Blend the tones out with a tortillon. With the pencil, add some tone to the background area. This helps define and create the light edge of the nose.

3 LIFT OUT HIGHLIGHTS
Continue to add tone and blend until the tones have been accurately produced. Use a kneaded eraser to lift out highlight areas.

How the nose relates to other features

Accurate placement of the facial features is essential for obtaining a good likeness. The nose acts somewhat like a "center weight" for all of the other facial features. If the nose is not drawn in the proper shape and size, it will throw the rest of the features off.

As a general rule, the nose is measured from the bridge, between the eyes, down to underneath the nostrils. That distance will be equal to the distance from the bottom of the chin up to the nostrils.

The base of the nose will also give a reference point for the earlobes, if you measure across. And the space between the eyes, above the nose, is equal to one eye-width. This width will also give you the width of the nostril area.

Go through magazine pictures. Find faces that look straight ahead, without any tilt or turn to the head, and see how these general rules actually apply.

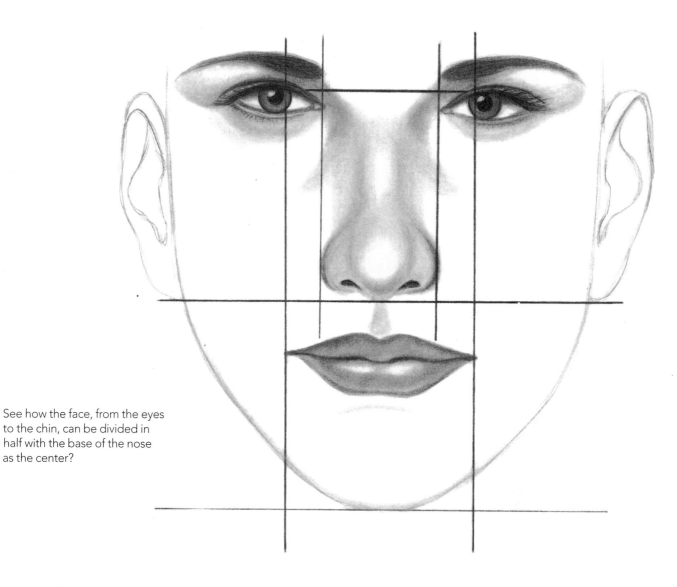

See how the face, from the eyes to the chin, can be divided in half with the base of the nose as the center?

Important Points to Remember

1 The nose is made up of soft edges where it gently curves and hard edges where the planes overlap or touch.

2 Look for the basic shapes within the nose.

3 Look for your light source and the shadow placement.

4 Use your five-box value scale to apply your tones.

5 Look for the reflected light around the edge of the nostrils.

6 Make sure you have an accurate line drawing before you begin blending.

7 Draw from the illustrations in this book for practice.

8 Never use outlines.

9 Study the relationship of the nose to the other features.

10 Practice!

11 Practice!

12 Practice!

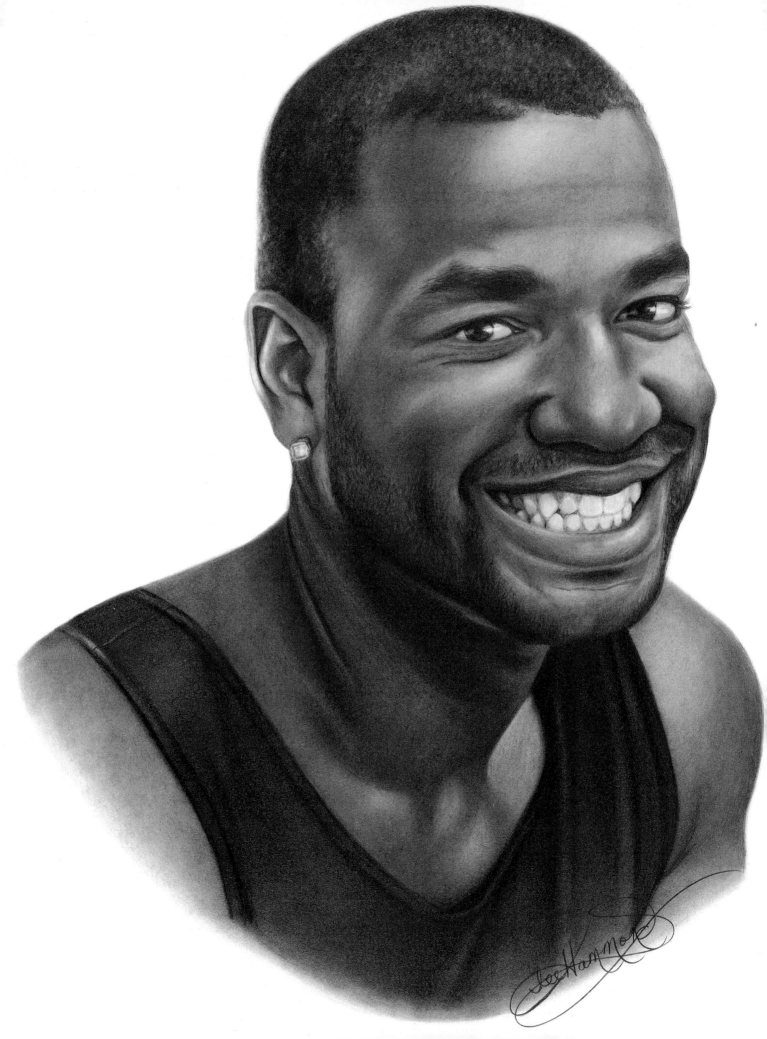

4 Drawing the Mouth

Because the mouth does not seem very complex, especially when closed, we have a tendency to simplify it in our drawings. The mouth, much like the nose, must be seen as *shape*, with all the elements of shading applied to it.

Study the examples of the mouth on the following pages and see if you can identify where the five elements of shading are. Since the mouth does not project outwardly off of the face as much as the nose, there will not be as dark a cast shadow below it, so the darkest dark, or number one on your five-box value scale, will be seen in the corner of the mouth, which is called the pit. The shadows below the mouth remain fairly light, like those of a halftone. The highlight or full light area of the lower lip is easy to see. Reflected light, which is always the hardest to see, can always be found on the upper lip, just above the edge where the two lips touch.

KELYN BLOCK
Graphite on smooth bristol • 17" × 14" (43 × 36cm)

Drawing women's lips

When looking at the lips and their tones, you will see that the upper lip is always darker than the lower one. This is due to the angles at which the lips protrude. The upper lip, although pushed out farther because of the teeth, angles inward so it receives less light. The bottom lip, on the other hand, has a downward thrust that acts like a shelf to reflect light. This is why, when the mouth is shut and the lips are together, you will see reflected light on the upper lip, along the edge where the two lips touch. The light is being bounced back up from the lower lip.

Never draw the mouth and lips with a harsh out-line around them. As we learned with the nose, this will make them appear flat and unreal. Instead, allow the tone of the lips to come up and create an "edge." Sometimes women's lips will appear outlined due to their lipstick, but keep the edge looking soft by blend-ing the edge into the lip.

It's not necessary to draw every line and crease you see in the lips. Usually the one in the middle of the lower lip is the most noticeable and helps give the lip its shape. The bright highlight on the bottom lip helps the lips look moist and shiny.

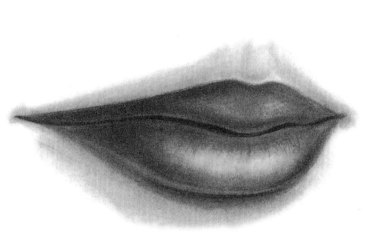

The upper lip is always darker than the lower one.

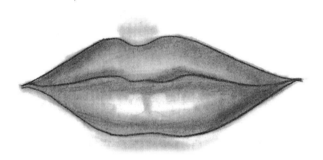

Never outline the mouth and lips.

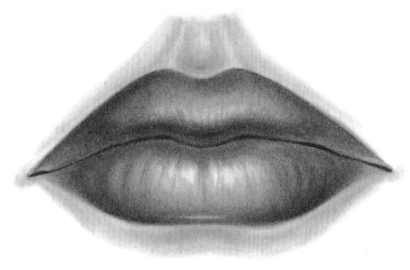

The lips are composed of tonal shapes, not harsh outlines.

The upper lip angles in while the bottom lip angles out.

Shading and shaping the teeth

The mouth becomes more complicated when the lips are open, allowing the teeth to be seen. Each tooth must be drawn accurately in size, shape and placement, or it has a profound effect on the likeness of your subject. Pay attention to the fact that the teeth are not really bright white, like we wish they were, but have shadows on them created by the lips. The actual shapes of the teeth are defined by drawing the gum line above them and the dark, triangular shapes below them. This will create the shape of the teeth gently instead of drawing around each tooth separately. The separation is not dark but very subtle.

Although lips are often very rounded, there are many angles that are created by their shape. When a mouth is seen from a three-quarter view, as the one at top, it's important to study these angles to prevent ourselves from drawing the mouth too straight on (our minds will want to draw everything from a head-on view). Sometimes the turn of the face is very slight. By drawing a line down the center of the mouth, you can clearly see that there is more of the mouth showing on the left side than on the right. If we fail to identify that small detail, we will probably draw the mouth too straight on and ruin the likeness.

Look for the many angles that make up the shape of the mouth.

See how the teeth are shaped by the gum line above? You do not see a hard line between each tooth. The upper lip casts a subtle shadow across the teeth.

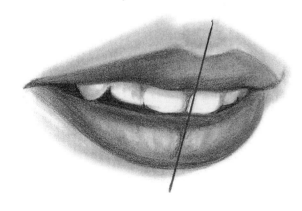

The teeth are also shaped by the dark spaces below them. Placing a center point helps keep the proportions accurate.

The highlight on the lower lip makes it look moist.

Drawing men's lips

Men's lips are usually much less defined than women's. Lipstick can make women's lips look a lot darker than they are, making the shadows of the mouth harder to see. Because a man's lips will appear lighter in color and less defined, the shadows that make up the lips' shapes are more noticeable.

The lips are a part of the continuous shape of the face. They really are nothing more than an area of darker pigment that protrudes slightly. Because they stick outward a little bit, they cast shadows and they reflect light.

When drawing men's lips, rather than trying to create "lips," look for the shadows above and below them.

Sometimes it is the shadow itself that defines the shape, and there is no actual outline to the lip at all.

There may also be times when the lips are barely discernible and their characteristics very subtle. In cases like these, we will always have the tendency to try to put more into our drawing than is really there. Again, this is due to our minds telling us how a mouth "should" look, rather than drawing what we actually see.

Study your photo carefully before you begin to draw. See the lips as they actually are. If they are subtle and undefined in the photo, they should be subtle and undefined in your artwork, too. Draw only what you *see*.

If the details are subtle in your photo, they should be subtle in your artwork too.

Drawing the mouth step by step

Now let's try drawing the mouth in three easy steps. Follow the same procedure as you did for the nose, beginning with your line drawing, applying your tones, and then blending your values and adding details.

1 ACCURATE LINE DRAWING
Begin with an accurate line drawing. This is where all of your shapes create the foundation for your entire drawing. Be sure that the teeth are accurate in shape, size and placement. Highlights and shadows also should be drawn in as shapes.

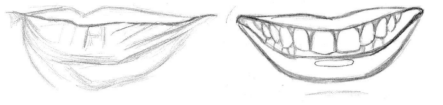

2 BLOCKING IN TONES
Block in your tones. Use your value scale to judge the depth of tone. Look for the shadows on the teeth, especially the lower ones. On the example at right, they can barely be seen, but they are still very important to the overall look of this mouth. Add any lip creases or lines that are important to the shape and character of the particular mouth you are drawing.

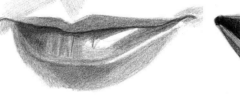
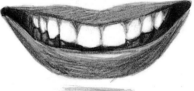

3 BLENDING AND DETAILING
Blend out your tones. Highlights should not be drawn around, but rather lifted with your kneaded eraser. This will make them appear as if they are reflecting off the top surface of the lips. On the closed mouth, a hard edge is created where the two lips come together. Do not draw this as one continual, even line. Close observation will show that this line varies in width and in tone. The "pit" of the mouth at the corners is essential to make the mouth seem as if it is sinking into the face, not just lying on top.

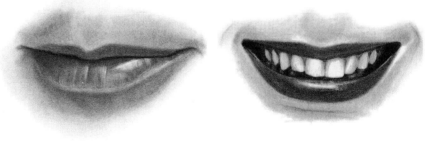

Graphing the mouth

Here you can see that for a closed mouth, I have used a 1-inch (25mm) grid. This is because on a closed mouth the shapes are not complex, and can easily be contained in the larger squares. Again, see everything as just shapes and draw what you see in just one box at a time. Include the nose and the chin in your drawing. This will help prepare you for drawing the entire face. Note that the skin is not white, and should be drawn as a halftone.

Graphing a photo of an open mouth will give you practice with the teeth. I have used a ½-inch (13mm) grid on this photo in order to draw the placement of

the teeth accurately. The ½-inch (13mm) grid gives you less room for error. Although the teeth are very white, there are shadows and bright highlights on them. A comparison of the tones between the teeth and the skin shows you just how much darker the skin is when compared to white. To capture the highlights on the lips, nose and teeth, lift them with your kneaded eraser.

For additional practice, go through your magazine references and draw as many mouths as you can. Try both male and female, in as many different poses as you can.

Using a 1-inch (25mm) grid is fine for drawing a closed mouth.

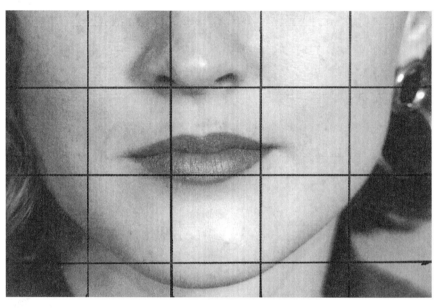

A ½-inch (13mm) grid makes it easier to draw the teeth accurately.

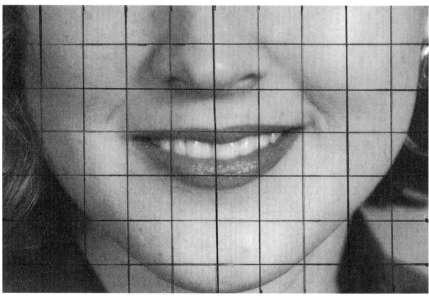

Practice drawing the closed mouth

Let's practice drawing from the photos provided. When you are sure of your accurate line drawing, carefully remove the grid lines from your drawing paper with the kneaded eraser and follow along.

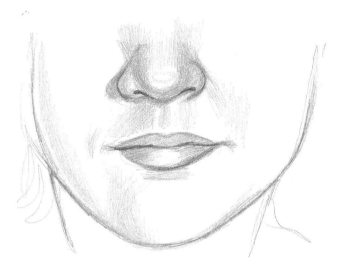

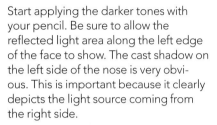

Start applying the darker tones with your pencil. Be sure to allow the reflected light area along the left edge of the face to show. The cast shadow on the left side of the nose is very obvious. This is important because it clearly depicts the light source coming from the right side.

Gently blend out the tones to make them appear smooth and gradual.

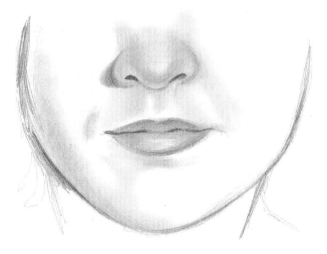

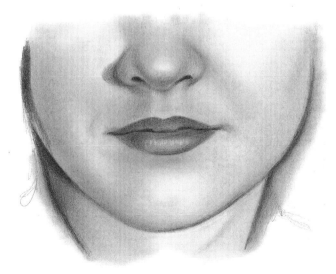

Continue building the tones and repeat your blending with the tortillon until the tones look accurate and smooth. This is where you must analyze all of the lines applied and turn them into "edges." Look at how I added some darkness into the background to make the outline of the face disappear. This now creates a light edge to the face instead of a dark outline.

Use the kneaded eraser to lift the highlight areas on the tip of the nose and the lower lip.

Practice drawing the open mouth

Using the second graphed photo on page 46, follow along with the steps below to create the open-mouth smile.

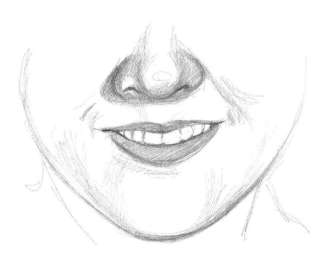

Start applying the darker tones with your pencil. Be sure not to over-draw the teeth. The line between each one should not be overly dark. Use the subtle shapes of the gum line to help draw the shape of each tooth.

Gently blend out the tones to make them appear smooth and gradual.

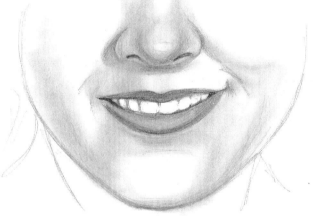

Continue building the tones and repeat your blending with the tortillon until the tones look accurate and smooth. Just as in the previous example, this is where you must analyze all of the lines applied and turn them into "edges." Even the teeth are shaded now to soften the look of the line between them.

Use the kneaded eraser to lift the highlight areas on the tip of the nose, the lower lip, and all of the teeth. This is what makes them look shiny wet, and realistic.

Drawing facial hair

Now that you are becoming comfortable drawing the nose and mouth, you are ready to take on more of a challenge. This is a good time to try drawing a mouth with a mustache or beard, since in portrait drawing, many of your subjects will have them.

A mustache or beard has fullness and depth. It must be built up in layers to give it the fullness it needs in order to look real. This is also a good introduction to drawing hair, which we will cover in Chapter 8.

There are many things to look for when drawing facial hair. Not only are the shapes important, but the coloration of the hair must be considered. Stop and look to see how the color of the hair looks next to the skin. Is it light against dark, or is the mustache darker than the skin? Also, does the entire upper lip show, or is it partially covered by the mustache? The pattern of hair growth, especially in the beard, is different and unique for each man. All of these factors—shape, fullness, coloration and growth pattern—must be carefully studied and accurately drawn in order to render a true likeness. Drawing generic-looking facial hair will make your portrait look like a cartoon.

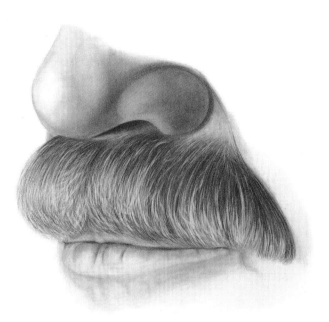

Drawing a mustache can be fun, and can be done very realistically. It is important to see its relationship to both the nose and the mouth. The nose casts a shadow on the mustache, and the mustache will cast a shadow on the mouth. If the mustache is very full, it will often cover the entire upper lip.

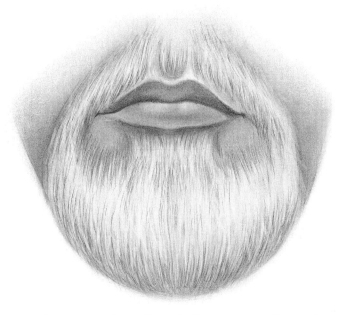

Often a mustache and beard will connect together on the face. The lips on this subject are also full and clearly seen, but unlike the first illustration, the facial hair is light against the skin instead of dark. The roundness of the beard is created with shadow to look as if there is a chin underneath. Once again, the light hair lines have been picked out with a kneaded eraser.

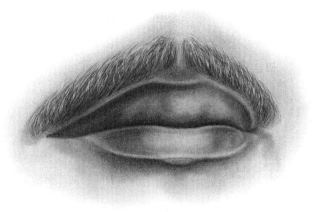

This mustache is very dark, short and somewhat coarse. Because it is short, the edge of the upper lip is showing. There is a rim of light above the lip that separates the lip from the mustache. Notice how the illusion of fullness is achieved by lifting out some light hair lines on top of the dark ones with a kneaded eraser.

Drawing facial hair step by step

It is important to build up the facial hair in layers, just like the hair actually grows, to keep it from looking flat, thin and unnatural. Remember that underneath the hair is the facial structure. You must study the shape and proportion of the upper lip and chin to avoid drawing a beard that looks pasted on.

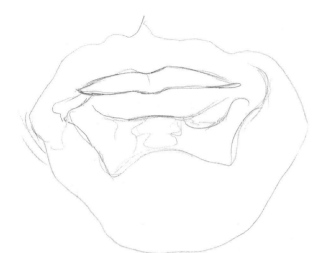

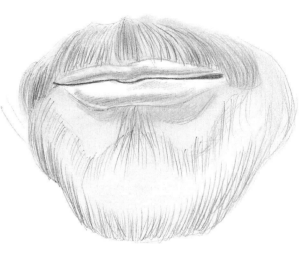

1 LINE DRAWING
Begin drawing the beard and mustache by blocking in a line drawing of the entire overall shape. Watch for the shapes or patterns of hair growth between the lips and beard.

2 TONES AND STROKES
Now begin to apply your dark areas, such as the shadow edges on the lips and the mustache hairs above the lip. Blend out the mustache. Apply tone to the skin area below the bottom lip and blend out. Begin to build the shape of the beard with quick strokes around the edges, and blend that out too. Everything at this point will be somewhat of a halftone, except the lips.

3 LIGHTS AND DARKS
The halftones serve as a foundation for building up the depth and details. Darken the mustache and beard using quick, tapered pencil strokes. Lift out some light, highlighted hairs with the kneaded eraser. Keep applying lights and darks until you create the fullness you need, and the correct coloration. Finish your drawing by lifting some stray hairs that overlap the others.

Drawing stubble and whiskers

The following will give you practice drawing someone with a five o'clock shadow. The basic procedure is the same, but the small hairs of the stubble make this much more time consuming.

This is the face of a man from a project on page 103. If you want to, simply read this material now, and refer back to it when you do the full face project later.

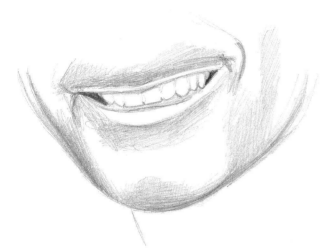

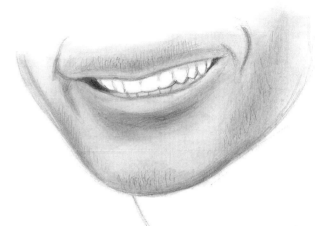

1 LINE DRAWING
Begin with an accurate line drawing depicting the shape of the mouth and chin area. Start adding tones with the pencil to begin developing the contours of the face. Before any facial hair can be added, the tones of the face must be in place first.

2 TONES AND STROKES
Blend the tones of the face to make them appear smooth. Once the blending is complete, you can begin adding some very short, quick strokes for the whiskers. Remember, all hair is created with pencil strokes, and the length of the hairs are represented by the length of your strokes. These hairs are so short in areas that it is almost like "stippling" with small dots of the pencil point.

3 LIGHTS AND DARKS
Continue adding the small hairs with your pencil, concentrating them is the darkest areas around the edge of the chin, above the upper lip and the creases of the side of the face. This is a time consuming process, so do not get frustrated if it takes awhile.

When you have enough of the dark whiskers, add some of the light ones by shaping a small piece of the kneaded eraser into a point and quickly lifting them out. This takes practice. If your strokes look too wide, simply go on either side of it with your pencil to thin them out. Continue going back and forth, creating both light and dark strokes until you have the appearance of facial stubble.

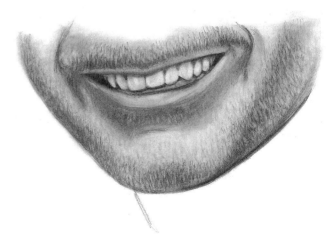

Portrait of Christopher

When portrait drawing, it is not always necessary to draw a person from the front. A profile view can make a very interesting portrait, and this is a good example of what can be created using the blended pencil technique.

The darkness of the facial hair helps balance the darkness of his other hair, giving the piece tonal balance.

Study this example closely for everything we have learned so far. You can see how all of the outlines have been turned into edges and how smoothly the tones have been blended.

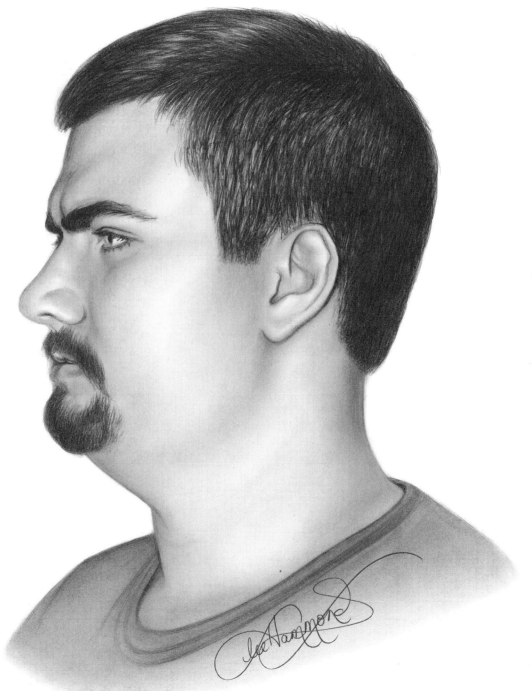

CHRISTOPHER DALE HAMMOND II
Graphite on smooth bristol • 17" × 14" (43 × 36cm)

Important Points to Remember

1 Never outline the mouth.

2 The upper lip is always darker than the lower lip.

3 Check the angles that make up the lips to accurately draw the pose.

4 Look for the shadows on the teeth.

5 Teeth must be accurately drawn in size, shape and placement.

6 The gum line and the areas below the teeth will help define their shape and placement.

7 Men's lips are less defined than women's and are often created by shadows.

8 Use a ½-inch (13mm) grid to help draw the placement of the teeth.

9 Mustaches and beards must be drawn in layers to achieve depth and fullness.

10 Practice!

11 Practice!

12 Practice!

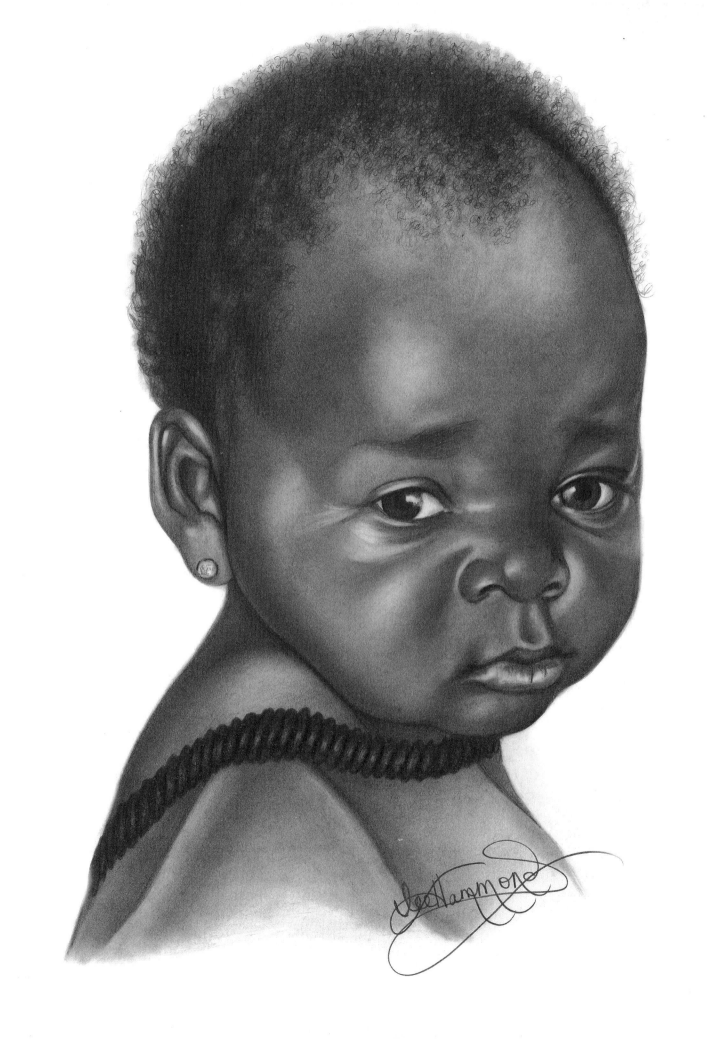

5 Drawing the Ear

Drawing the ear can be confusing because the ear is made up of many interlocking shapes. This is where the Puzzle Piece Theory will help you—you'll see the ear as nothing more than shapes and forget that it is an ear.

Not only does the ear contain many different shapes, it also has a variety of tones. Because of its curved, rounded surfaces, it has many shadow edges and areas of reflected light. Since the ear is not flat to the head but projects outward, there are also cast shadows. Add to these things the fact that you also have hair to deal with, and you can see how drawing the ear can become a bit of a challenge.

This is where you'll find out how well you see shapes and how important the elements of shading really are. The good thing is that on an average portrait, you usually will not see the entire ear.

PORTRAIT OF AFRICAN BABY GIRL
Graphite on smooth bristol • 14" × 11" (36 × 28cm)

Look for interlocking shapes

Begin by studying the curves and shapes shown here. All of the five elements of shading are represented, from the deepest tone in the cast shadow to the white of the highlighted rim. Gradual blending of tones gives the rounded, three-dimensional look to the many folds and curves of the ear.

Shadow edge shows roundness

Reflected light separates two shadows

Hard edges due to overlapping surfaces

Full light areas

Halftones

Cast shadow

Shadow edge

Reflected light

Cast shadow

Shadow edge shows roundness

Graphing the ear

Graphing the ear will help you see all the interlocking shapes. By paying strict attention to the shapes inside one box at a time, the entire ear will take shape. A ½-inch (13mm) grid will help you with the details. Be sure to include the hair and the shadows surrounding the ear.

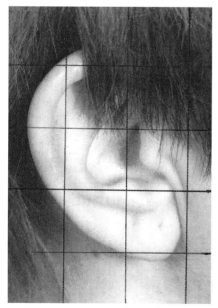

Graphing the ear will help you see its shapes.

Draw one box at a time. Include the hair and the shadows.

Drawing the ear step by step

The ear, as you have probably already noticed, is very different from the rest of the features. Not only is the shape unique, but the skin and texture are totally different. The ear is oilier, so it will have more of a shine to it.

These bright highlight areas are important to its overall look. Because of the many areas of overlap, the darks can be very extreme. Be sure to study the shapes carefully, and see where there are "shapes within shapes."

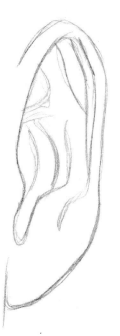

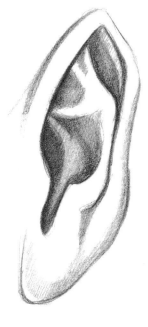

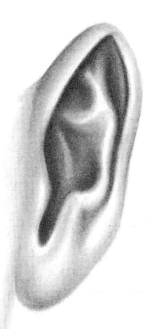

1 ACCURATE LINE DRAWING
Begin with an accurate line drawing. Do not remove your grid and begin your shading unless you have double-checked your shapes for accuracy.

2 PLACEMENT OF TONES
Fill in your dark areas and tones. Look for the hard edges that are created by overlapping surfaces. Keep your edges crisp, but be sure not to outline.

3 BLENDING
Blend your tones from dark to light. Pull out your highlights with a kneaded eraser. Look for where edges are reflecting light. Remember, anything with an edge, a rim or a lip will reflect light.

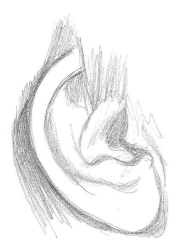

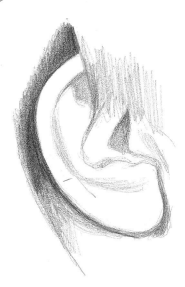

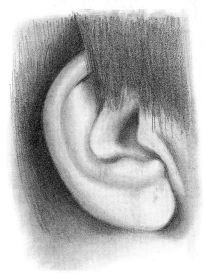

Look for contrasting edges

It's very important to study the "edges" that are found on the ear. When the ear alone is drawn, as seen in the example below, there is no cast shadow below the earlobe. Because of this, the edge of the earlobe appears dark. The other two examples show how the ear creates a cast shadow on the neck. You can see that the edge of the earlobe appears light against the cast shadow, and the reflected light separates the edge of the lobe from the surface beneath. This is what makes the earlobe seem rounded and three-dimensional.

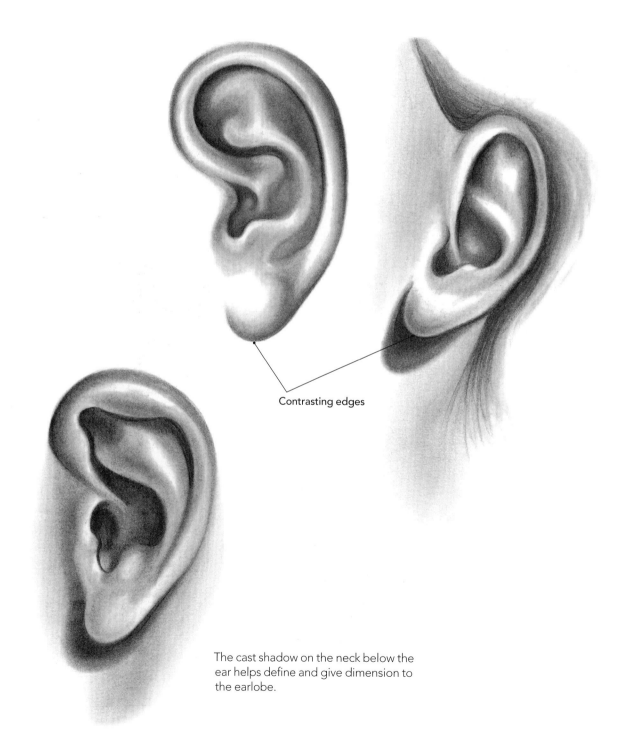

Contrasting edges

The cast shadow on the neck below the ear helps define and give dimension to the earlobe.

Personalizing the ears

Rarely will the entire ear be seen in the average portrait. Jewelry and hair will often hide a great deal of it. It's important to practice these variations. And although ears are somewhat general in their anatomy, everyone's ears have their own characteristics, whether they be in the size or the shape. Often wrinkles and lines make them more realistic and personal. And look for differences in the earlobes—some are connected to the jawline while others are long and dangling.

A front view of the ear will foreshorten the shapes that are found within it.

The hair, which will often come across the ear, should appear convincing. Fine hair lines can be lifted out with the eraser. The pearl earring looks like an exaggerated version of the sphere exercise.

Many people have creases in their earlobes, which is part of their unique appearance.

Placement of the ear

Although the ears vary in size and shape from person to person, there are some general guidelines that will help you with their placement.

By studying the diagram below you can see that the ear does not sit straight up and down on the side of the head, but is angled backwards. The top of the ear will line up with the base of the eyebrow and the bottom will line up with the base of the nose, with that distance being equal to that of the base of the nose to the chin (3 to 2 equals 2 to 1).

On a profile view, the ear is about halfway between the back of the head and the front of the facial plane (not the front of the nose) (6 to 5 equals 5 to 4). The corner of the jawline descends from the front of the ear.

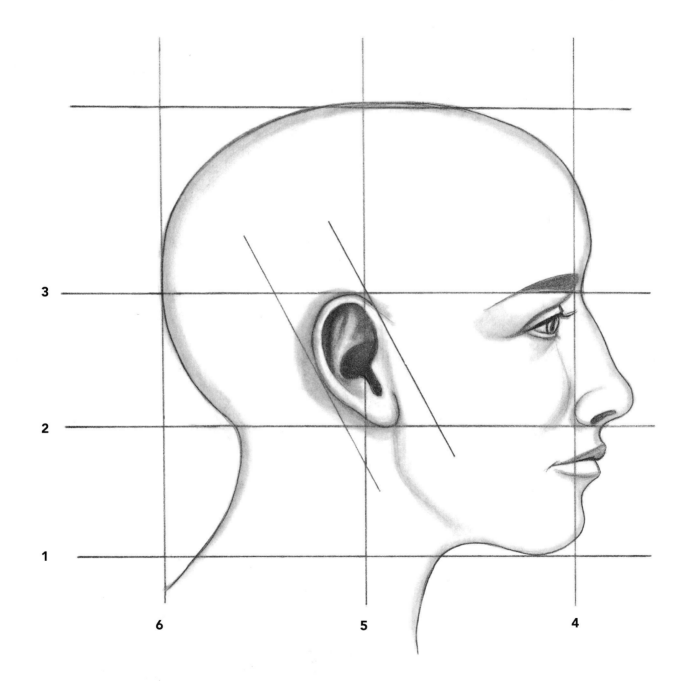

Important Points to Remember

1 Look at the ear as puzzle-piece shapes.

2 Watch for highlights and reflected light.

3 Watch for hard edges where surfaces overlap.

4 Placing tone behind the ear will help create the shape.

5 Look for the cast shadow created by the ear on the neck.

6 Practice placing hair and jewelry on the ears.

7 Keep in mind the relationship of the ear to the other features.

8 The ear is not straight up and down. Remember the tilted angle.

9 Practice!

10 Practice!

11 Practice!

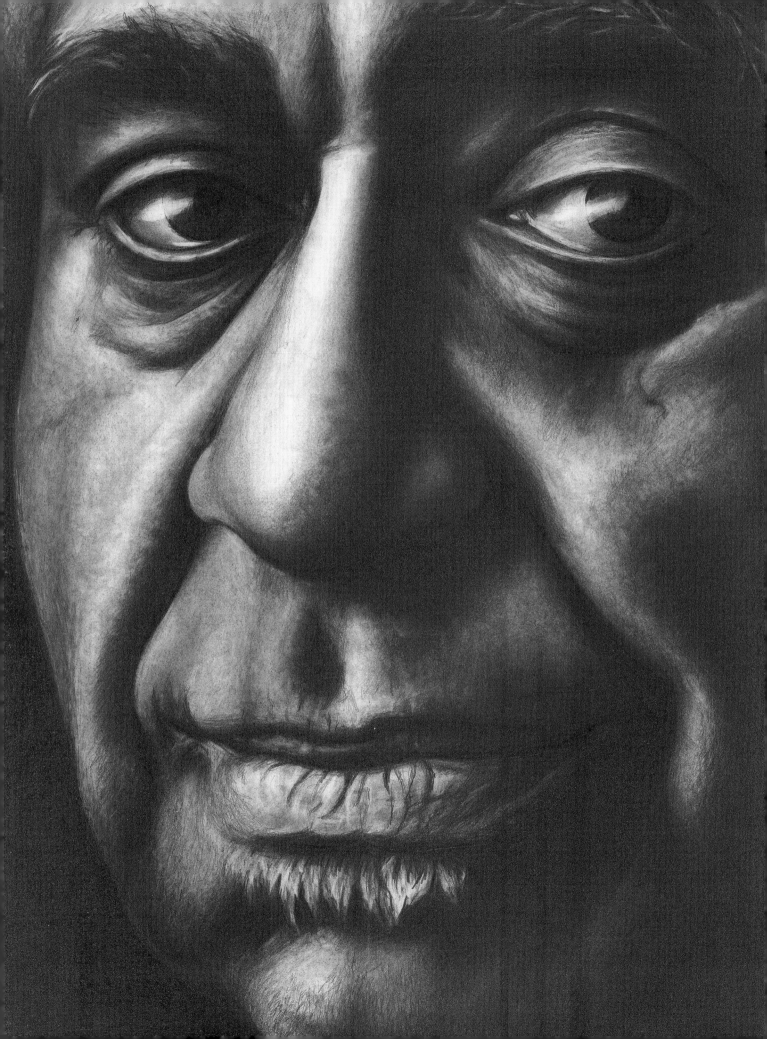

6 Drawing the Eyes

The eyes have often been referred to as the "windows to the soul" since they convey so much emotion and personality. For that reason, I find them to be the most important aspect of a good portrait. That is also why I begin all of my portraits with the eyes, rendering them first. By doing so, I can capture the spirit of the person right away, and I will always know early on if I have missed the personality of the subject in my work.

When drawing a portrait, we must draw the eyes of the person we are looking at rather than drawing generic eyes or eyes as we think they look. We must forget all preconceived images of the eyes and draw only what we see in front of us. Everyone has special characteristics that we must capture, and this can be done only by drawing accurately.

By looking at a finished drawing of an eye, you can see the many details necessary to make it look realistic. It is important to note the smooth blending from dark to light and the effective use of shadows on the white part of the eye. A very small portion of the white area is actually white. Most of it is really a combination of halftones.

PORTRAIT OF DIZZY GILLESPIE
Graphite on smooth bristol • 12" × 8½" (30 × 22cm)
Art created from photo © by John Reeves

The structure of the eye

We will begin by reviewing the structure of the eyeball and its placement in the face. You will notice that I said "in" the face. That is because the eyeball itself is quite large in comparison to what we actually see. It sits deep inside the bony structure of the face with only a fraction of its surface actually showing beyond the eyelids.

By studying these illustrations, you can see just how large the eyeball really is. From the front, it looks very much like the spherical shape we practiced our shading on earlier. See how the elements of shading are seen in both of them, with the exception of the cast shadow below the sphere? The full light area appears as a bright reflection due to the wet, shiny surface of the eye.

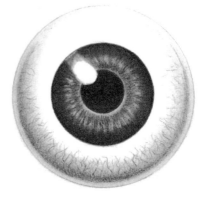

The elements of shading can be seen on the eyeball. Compare this with the sphere shown below.

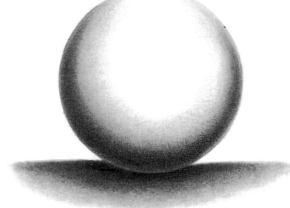

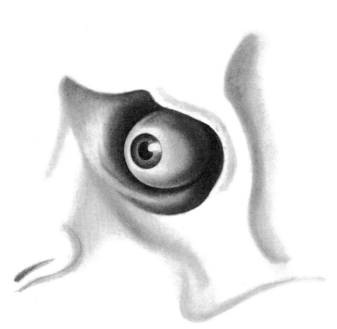

The eyeball sits "in" the face, deep inside the bony socket.

The eye in profile

From the side view, the eyeball has a bulge where the lens area protrudes. This gives it the appearance of an egg shape.

The illustration at right shows how the eyeball is placed behind the eyelids and how deeply it sits in the face. See how the eyelid is stretched over the eyeball and just how little of it we actually see? It is the curvature of the eyeball behind the lids that gives the eyelids their shape.

A good understanding of this shape now will help you later when we begin to draw eyes in various angles and positions. Often in a picture, especially of an unusual pose, shadows will hide the basic form from you. This general understanding will help you draw the shapes properly, even if you cannot see them well. It is this knowledge and understanding of the human form that earned the painters and artists of the past the title "masters."

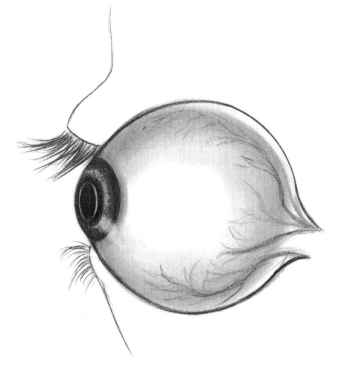

In profile, the eyeball is not round, but egg-shaped, due to the protruding lens.

Assembling the shapes

The eye is made up of many different shapes. By applying the Puzzle Piece Theory and drawing each piece individually—carefully checking for size and shape—all of the pieces, or shapes, will fit together to form the eye. In the diagram below, each shape has been numbered in the order in which it should be drawn.

Notice how the lashes, number nine on the diagram, have been treated as a solid mass. They create what is called a lash line, which is very dark and defines the curve of the upper lid. I do not put in individual lashes until the very last, when all of the blending has been completed.

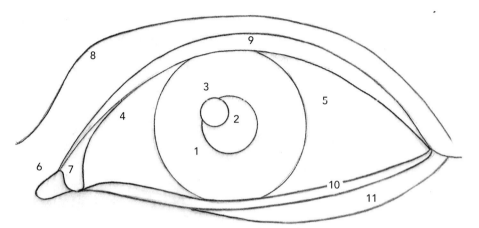

Draw each shape in the numbered order, starting with the iris and ending with the lower lid.

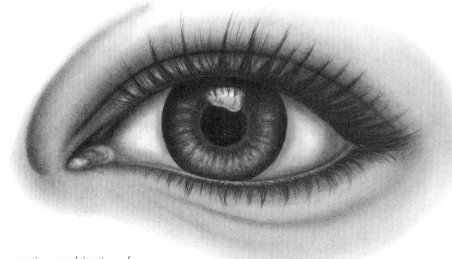

The eye is an amazing combination of color, texture, moisture and reflections.

Drawing the iris

Not only do we need to concern ourselves with the shape of the eye, but we also need to deal with the color of the eye, or the iris. This is very important when capturing a likeness since our eye color has a lot to do with our individual looks. For me, this is the most beautiful and challenging part of the eye. Even though we are drawing in pencil and dealing with nothing more than gray tones, we will be able to create the illusion of color just by the shades of gray we use in our drawing.

To judge the tones needed to duplicate eye color, picture a color photograph that has been reprinted in black and white. If you compared the two, each color in the picture would have a corresponding gray tone in the black-and-white print.

Eyes are much like a person's fingerprints, with no two exactly alike. Some irises will appear very smooth and pure in color, while others will have a great deal of patterning, almost like that of a kaleidoscope. The color of the eye will have a lot to do with the amount of pattern it has. A medium color such as green or deep blue will have the most design in it, with the highest degree of contrast and definition. A dark brown or pale blue eye will appear more smooth and even in tone.

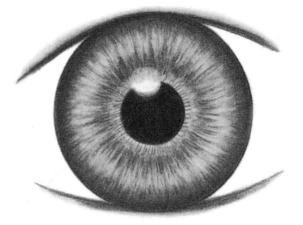

The depth of gray tone you use in the iris will give you the illusion of color.

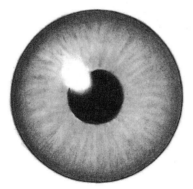

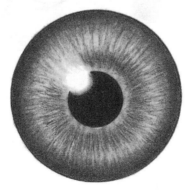

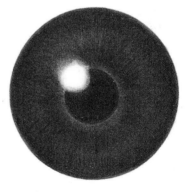

A blue eye A green, deep blue or gray eye A brown eye

Graphing and drawing the eye

Because the eye has many more details than the rest of the features, I have used the ½-inch (13mm) grid to isolate the shapes more effectively. Start your drawing by referring to the numbered illustration on page 66, where each shape is numbered in the order in which it should be drawn.

1 Start with number one, the iris. Freehand it in for placement, and then trace around a circle template to make it perfectly round. The iris is one of the only perfect circles in nature and should be drawn accordingly. If an iris is drawn out of round, it will look very odd.

2 Using your template again, draw in the pupil. This too is a perfect circle and is always centered in the iris.

3 Place your catchlight, which is the flash reflecting off of the eye. This should always be placed half in the pupil and half in the iris. If your photo reference shows more than one, eliminate all but one.

4 Once these circular shapes have been placed, draw in the rest of the surrounding shapes. Let their placement inside the box grid guide you. Be sure that all of the shapes are correct before you erase your grid lines.

A ½-inch (13mm) grid will help isolate the shapes and make them easier to draw.

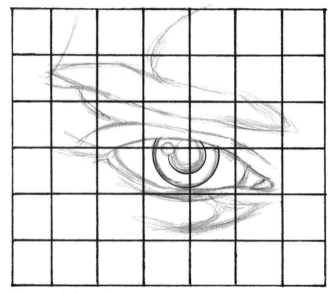

Be sure all of your shapes are accurate before removing your grid lines.

1 ACCURATE LINE DRAWING

In this line drawing, notice how the shadow shape under the eye has been drawn in. Also notice the area below the iris, or number ten on the diagram. This shows that the lower eyelid has thickness to it and the bottom of the eye is not just to be outlined. Look at someone's eye right now and you will see this detail. It is an extremely important element and is almost always left out in beginners' drawings. If you go back to the beginning of this book and look at the students' early work, you will find their first attempts did not include the lower lid.

2 PLACEMENT OF TONES

Now start to develop the patterns in the eye and the shadows both around the eye and on the eyeball. Don't forget your catchlight. Fill in the eyebrow as a solid tone for now, and do the same with the lash line. Individual hairs come later.

3 BLENDING

Blending creates the roundness of the eye. All of the tones are very gradual and smooth. This is when the lashes are put in. Apply them as "clumps," not single little hairs. Use quick strokes so the line will taper at the end. The bottom lashes are much smaller and thinner but are still in groups. The eyebrow is also made up of tapered pencil lines, following the growth of the hair. Unlike the lashes, they are gently blended out.

Shaping the eyelids

At the beginning of this chapter, we discussed how the lens of the eye creates a bulge where it protrudes. This bulge can be seen when the light reflects off the eyelid.

On these examples, notice how the shape of the eye is clearly evident beneath the eyelids. Whenever a surface protrudes farther than the rest of the object, the light will be stronger there. Practice drawing from these examples, keeping in mind the shape of the eyeball itself and how it is creating the shape of the eyelid.

Take your grid and lay it over these illustrations for practice. Apply the five elements of shading and practice judging your tones by referring to your five-box value scale. Go through magazine pictures and study the eyes in various poses. See if you can identify where the lens of the eye is catching light, and where a highlight appears on the eyelid.

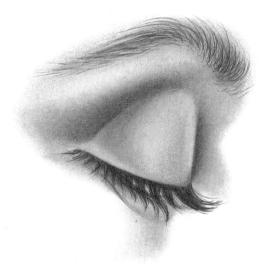

On this partially closed eye, the roundness of the eyeball can be clearly seen beneath the lid.

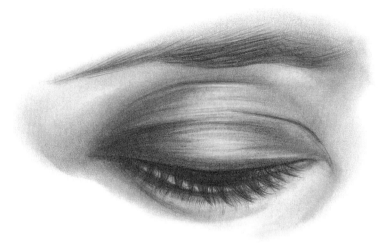

Where the lens of the eye stretches the eyelid, more light will be reflected.

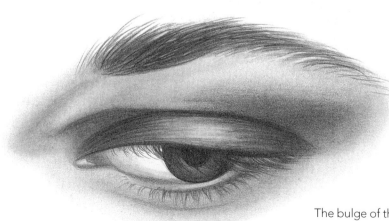

The bulge of the eye's lens can be seen on the upper lid. It also makes the lower lid thickness more obvious.

The angle of the eye

By looking at a side view of the eye, you can see how different our guidelines become. The iris, which will usually dominate the eye, can no longer be seen well, and the catchlight appears more like a streak than a spot or circle. The lens area where the eye bulges is almost clear and allows light to pass through it. The overall shape of the eyeball itself is very pronounced beneath the eyelids.

When the face is seen from the side, only one eye will be visible. The bridge of the nose will completely block the view of the eye on the other side. Notice how the eyebrow protrudes due to the brow bone.

The upper eyelid protrudes farther than the lower one, as can be seen in all three of these illustrations. There is approximately a 30-degree angle created by the way the eyeball sits inside the bony structure of the face. Always keep this angle in mind when drawing a profile.

The upper lid protrudes more than the lower lid, creating approximately a 30-degree angle.

The bridge of the nose blocks the view of the other eye. Most people do not realize how far back the eye sits in the face.

The pupil and iris are distorted on a side view. The lens is "clear" and the catchlight is no longer a circular spot.

Drawing the eyebrows step by step

There is another part of the eye that plays a very important role in a person's appearance: the eyebrows. They have as much to do with the overall look of the eyes as the eyes themselves, and they have a lot to do with the expression you are trying to convey.

Eyebrows are easier to draw than you might think. But first you must analyze them and their placement on the face. Located above the eye and following the bony structure that surrounds and protects the eye, the eyebrow is made up of many individual hairs. Never draw it just as a solid mass sitting on top of the skin. To make the eyebrow appear real, we must make the hairs and the skin work together.

The examples here show both male and female eyebrows. See how different they are from one another? Men usually have thicker brows that are closer to the eye. Women's are usually more arched and defined.

1 SKETCH THE SHAPE
Start by giving yourself a light outline of the shape, and then study the direction of the hair growth. Create the illusion of hairs by applying quick pencil strokes with sharp outward wrist motions in the direction that the hair is growing. This will make the lines taper on the ends.

Female **Male**

2 APPLY STROKES AND BLEND
Start at the base of the brow where the hairs are thicker, applying strokes until they appear to overlap one another. Blend the whole thing out to give the illusion of a shadow created by the hairs on the skin. After blending, add more strokes to create density.

3 BUILD UP LAYERS
Build up the layers until you get the volume and tone you need. With your eraser, pick out some highlights for contrast. This will give the illusion of layers with the top hairs reflecting light.

The direction of gaze

Both the eye and the eyebrow are affected by the way the head is tilted and the direction the eye is looking. The first example below shows what happens when the head is tilted downward and the eye is looking up. The eyebrow seems much closer to the eye, and more shadows appear on the white of the eye. Also, the white of the eye is now evident under the iris. This happens only when the eye is looking up. Usually the lower lid cuts across the iris.

The second drawing shows what happens when the eye is looking to the side. The eyebrow runs into the bridge of the nose, with the inner corner of the eye being hidden. There is much more white of the eye showing on the left than on the right.

In both of the examples, see how much more visible the thickness of the lower lid is?

Notice how the white of the eye is showing below the iris when the gaze is directed upward.

When the eye is looking to the side, the eyebrow will run into the bridge of the nose.

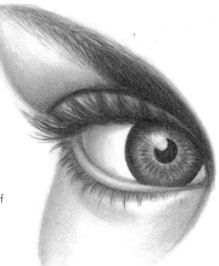

Drawing men's eyes

Men's eyes can seem much more complicated and intense. Due to the eyebrows usually being larger, the shadows and contrasts are more extreme. Watch for all of the little details and characteristics that are important to the subject's personality.

Here is a checklist to review as you practice drawing from this example.

1. Draw your iris and pupil with a template so they will be perfect circles.

2. Include all eleven parts of the eye, as shown in the diagram on page 66.

3. Remember that there are shadows on the eyeball itself.

4. Do not forget the lower lid thickness.

5. Do not draw eyelashes one hair at a time. On this example, you barely see any lashes.

6. Keep your blending smooth and gradual to mimic the look of skin.

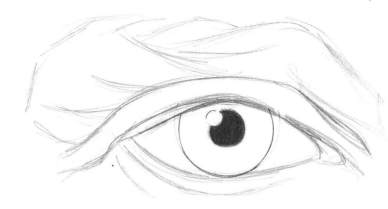

1 ACCURATE LINE DRAWING

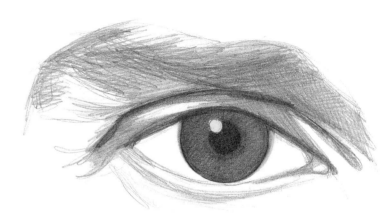

2 APPLICATION OF TONES

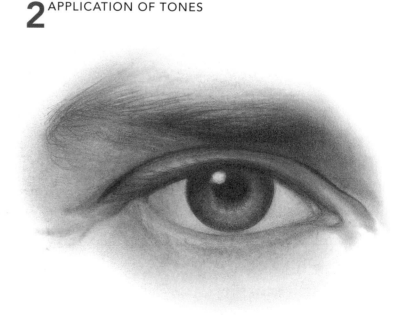

3 GRADUAL BLENDING

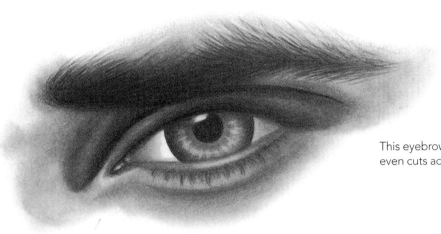

This eyebrow is very close to the eye; it even cuts across the upper eyelid.

Eyebrows and wrinkles help describe a person's personality, mood and age.

This deep-set eye looks very intense. Notice the use of shadows and the way the catchlights make the eye look wet. Usually in a proper, posed portrait, I would have eliminated all but one of the catchlights; I left these in for visual impact.

Placement of the eyes on the face

The example below shows how the eyes work together with the nose in a straight-on view. If you measure the distance between the eyes across the bridge of the nose, from inside corner to inside corner, you will find it to be exactly one eye-width. By drawing a line down from the inside corner of the eye, you will find that the widest part of the nose is also one eye-width. Test this theory by going through your magazine pictures and measuring them. Be sure they are front views, with no tilt or turn. Go to a mirror and see how these principles apply to your own face.

It should be noted that these guidelines are general. Bone structures of other individuals will differ.

When drawing a face that is partially turned away from a straight-on view, such as the examples at right, it is critical to draw the angle of the eyes correctly. By drawing a horizontal line under one eye at its lowest point, you can see how much higher one eye is than the other. By passing lines through both eyes from lid to lid, you can see just how acute the angle really is. Unfortunately, our minds make us want to draw eyes straight across. By drawing some guidelines on your photo reference, you can overcome this tendency.

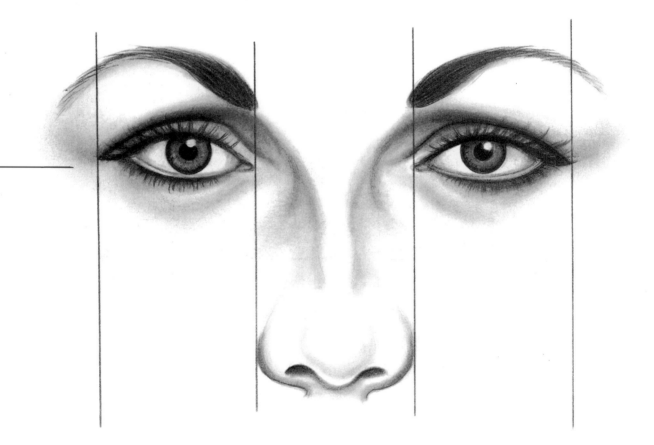

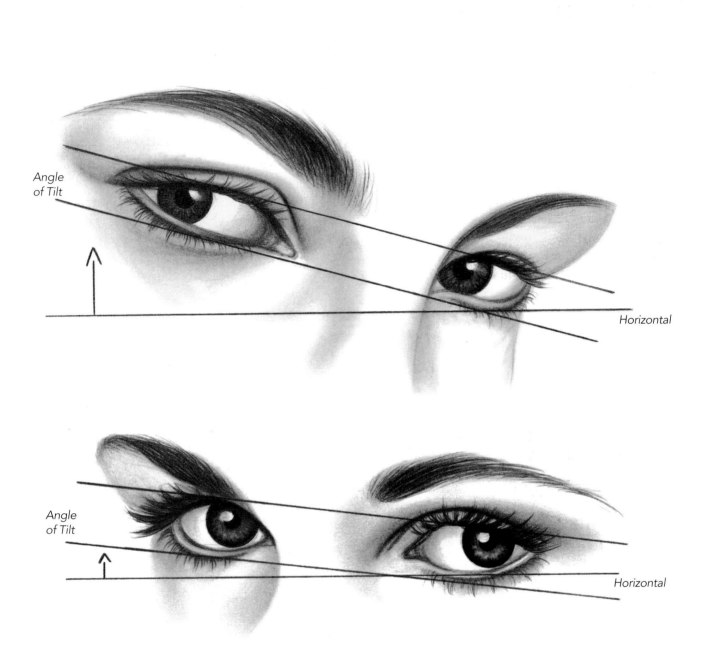

Angle
of Tilt

Horizontal

Angle
of Tilt

Horizontal

Although these eyes seem to be straight across, placing guidelines proves that the head is at a slight tilt, with the subject's left eye being lower.

Horizontal ellipses

Up until this point we have been drawing mainly eyes that are looking straight at you. When this is the case, the iris and pupil are perfect circles. But what happens to those circles when the eye looks away from you?

Think of the edge of a drinking glass. When viewed from above, the rim appears as a perfect circle, just like the iris. But when viewed from across the table, the full circle can no longer be seen. Our perspective changes,

and we see a circle that has been tilted and condensed. This condensed, flattened circle is called an ellipse.

The same thing happens when the eye looks away from you, although the changes are much more subtle. Study the example below, and see how the perspective of the eye and iris change according to the direction the eye is looking.

Horizontal Ellipses
A circle that changes from full to condensed or flattened is called an "ellipse."

When the eye looks up or down, the iris becomes a horizontal ellipse. The lids cutting across the iris make the ellipse more noticeable. Can you see the reflected light on the inside rim of the upper lid?

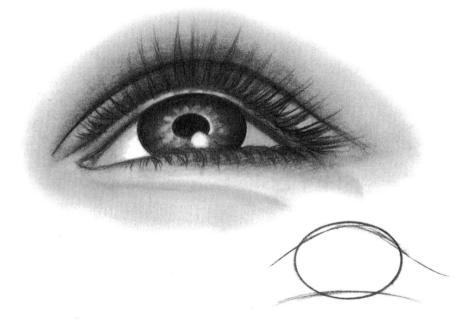

Vertical ellipses

Sometimes you will have to look closely to see vertical ellipses. They can be very subtle. These examples show what happens when the eye looks from side to side or when the head turns away from a straight-on view.

Notice that the pupil also turns into a vertical ellipse, but it still needs to be centered in the iris. To draw your ellipses correctly, you will need to use a template, just like the one you use for circles, only this one will have a variety of ellipses. Do not try to draw your iris and pupil freehand. It is too easy to get them uneven, and it will affect the quality of your work.

Vertical Ellipses

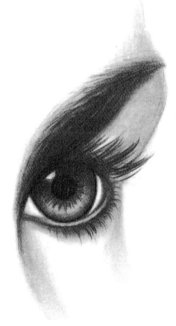

Although the iris of this eye appears to be a circle, it really is a very subtle vertical ellipse.

Even though the iris and pupil are now vertical ellipses, they still need to be centered with one another. See how the eyelids cut across the iris?

79

Children's eyes

So far, we have been dealing only with adult eyes. In your portrait drawing days ahead, you will probably want to draw children, whether your own or someone else's. Children make wonderful subjects with their smooth features and cheerful expressions. When drawing a child's eyes, you will find many differences, depending upon the age of the child. The eyes change as a person grows from infancy to adulthood, just like the other facial features.

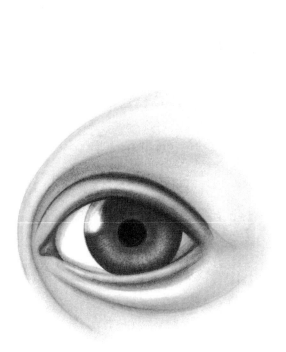

The overall shape of an infant's eye is very round, since the facial bones are not as pronounced at this age. Notice how big the iris appears, since it is full size at birth. It is smooth in color, with little speckling. The eyelashes have not developed much and may not show.

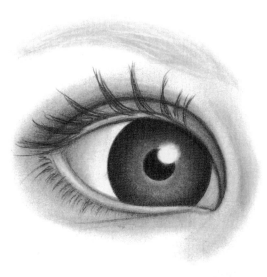

On a toddler, the lashes begin to fill in, as well as the eyebrow. Notice how light it appears. The coloration of the iris is still smooth, and the overall eye is still very round when compared to that of an adult.

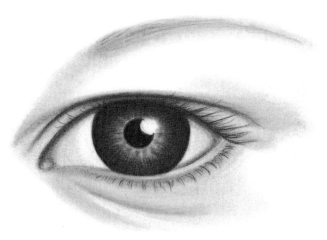

As the child grows older, the bony structure begins to take shape around the eye. The patterns of the iris are beginning to develop, as well as the thickness of the eyebrow.

Expressive eyes

So much expression can be seen in the eyes! Depending on how the facial muscles surrounding the eyes are working, a great many emotions can be expressed. Wide open eyes and raised eyebrows give the impression of surprise, fear or apprehension.

Tightly squeezed lids and the gathering of all the muscles toward the front of the forehead shows an intense individual. Whether it is physical pain or mental anguish, all of the emotions can be seen in the eyes. Closed eyes can make you feel calm and relaxed just looking at them.

Although you probably will not encounter this extreme of moods in portrait drawing, there may come a time when you will want to draw character studies. This gets you away from a posed portrait and illustrates what a person is feeling and doing.

It's fun to collect as many different expressions as you can with your magazine pictures. Try to capture the mood of the subject just by drawing the eyes.

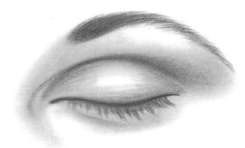

Graphing light and dark eyes

Here are two photo examples for you to work from. Both of these models have their own special qualities. Notice how the eyes of the model on this page are fairly light, with the eyelashes not very evident. The lower lid

thickness is not as obvious because the light lashes do not contrast with it. The eyebrows are fairly light and close to the eyes.

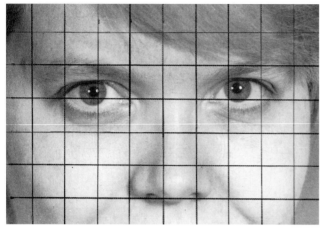

Reference photo showing light eyes. Using a ½-inch (13mm) grid will help you see the details.

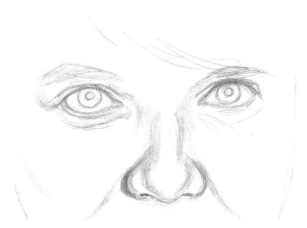

Carefully remove the grid lines from your drawing paper with a kneaded eraser. Start the rendering by adding the darkest area with your pencil. Create the cast shadow on the left side of the nose, as well as the shadow edge. You can see reflected light along the edge of the nostril.

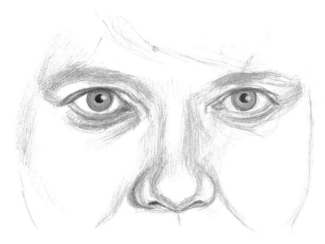

Develop the tones in the iris of the eyes. They are blue, so the tone would be a fairly light gray. Eliminate one of the catchlights from the photo, placing one half in the pupil and the other half in the iris. Blend the iris area to make it appear smooth.

Add some tones to the eyebrow area and under the eyes. Make sure not to outline the eyes heavily, but allow the lower lid thickness to show.

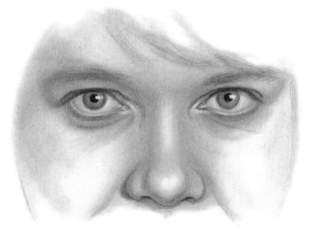

Blend the tones of the face to make everything smooth and even. After blending the areas of the eyebrows, add small pencil lines to represent the hairs. Her brows are very faint; do not overdo them!

The eyeballs themselves have slight shading to them in the corners. This helps them look rounded like spheres.

Use the kneaded eraser to lift the highlights in the eyes, and on the bridge and the tip of the nose.

This example shows how dark brown eyes look. It's hard to see which is iris and which is pupil. Also, the eyelashes are quite long and dark, which shows off the lower lid thickness.

Both of these photos have double catchlights in the eyes. Reduce this in your drawings to one in each eye. Make sure they are half in the pupil and half in the iris, and in the same place in each eye.

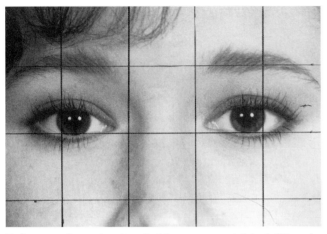

Reference photo showing dark brown eyes. A 1-inch (25mm) grid will work here because there are fewer details.

Carefully remove the grid lines from your drawing paper with a kneaded eraser. Start the rendering by adding the darkest area with your pencil. These eyes are very dark. Place black in the pupil first, then fill in the iris with deep gray.

Blend the tones in the irises of the eyes with a tortillon to make them look smooth. Remember to eliminate one of the catchlights, placing half in the pupil and half in the iris.

Add some tones to the eyebrow area, the eyelid and under the eyes. Create the lower lid thickness. It is more obvious in this example due to the darkness of her eyes.

Create the form of the nose by adding tone along each side.

Blend the tones of the face to make everything smooth and even. Allow the tones to create the roundness and form of the face. After blending the areas of the eyebrows, add small pencil lines to represent the hairs. These brows are darker in color, and the individual hairs are more obvious. Use quick strokes in the direction of the hair growth. Add eyelashes with quick strokes as well.

The eyeballs have slight shading to them in the corners. This helps them look rounded.

Use the kneaded eraser to lift the highlights in the eyes and on the bridge of the nose.

Graphing the eye in profile

This photograph will give you practice drawing the eyes in profile. Remember, the iris and the pupil become vertical ellipses when viewed from this angle. Use the grid lines to help you with the placement of the features.

The lighting in the photo makes the front of the face appear very light against the background. In order for those highlights to show up in your drawing, you will need to blend some tone into the background of your work. Notice that the nose appears light against dark, but the underneath part of the chin, which is in shadow, appears dark against light. It is this type of observation that will make you successful in portrait drawing and proficient in capturing realism.

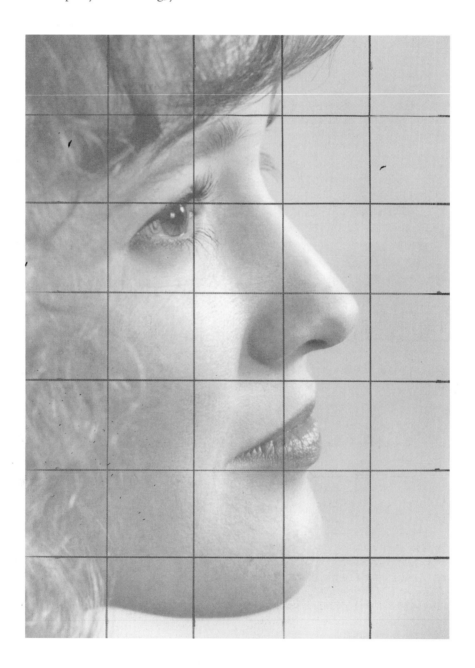

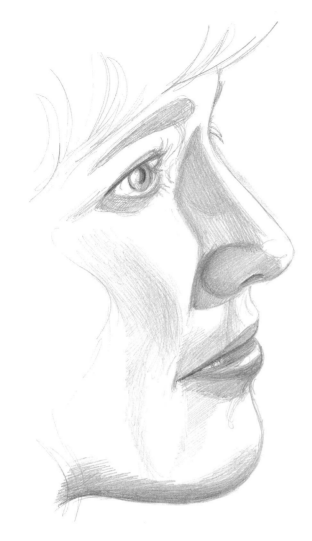

Once you have an accurate line drawing, carefully remove the grid lines from your paper with a kneaded eraser. Start your drawing with careful observation of the shapes. When dealing with a profile, the usual rules do not apply, although your brain will want to make them do so.

The iris in this eye is not a perfect circle. It is a subtle ellipse. Study the photo carefully and you can see how the direction of her gaze is looking slightly upward. You need to carefully place the iris inside the eye to capture this gaze. Do this first before going further. In the drawing I eliminated one of the catchlights, leaving only the one on the right.

Add the tones of the face with your pencil, starting with the eye area and then working down to the nose and then to the mouth. Carefully compare your tones as you go, for they vary from area to area. The deepest tones are seen in the mouth and along the underside of the face where it connects to the neck.

At this stage you can clearly see how the face is divided into the shadow areas and the full light areas.

Place some tone into the background on the right side to illuminate the light edge of the face. This eliminates the outline used when capturing the accurate line drawing.

Gently blend all of the tones with a tortillon to make them look smooth and gradual. Allow the shading to create the sphere-like shapes of the face. These are seen in the cheeks, the nose and the chin.

Look at areas that have subtle reflected light, such as the rim of the nostril, the lower lid thickness and the edge of the bottom lip. It is this type of detail that is often forgotten, but is crucial to capturing the realism of your subject.

Use a kneaded eraser to carefully lift out highlights and to create a clean edge between the face and the background. Lift the shiny reflection from the bottom lip.

Eyeglasses

Although it would be much easier to never draw people with eyeglasses, that is not very realistic. You will find as you do more and more portraiture that a good percentage of your subjects wear glasses. So it is very important to learn to draw them and draw them well. A good likeness of the person you are drawing will look ridiculous if the glasses he or she is wearing look like cartoons!

Look at how the eyeglasses can change the overall appearance of the eyes. They put the upper portion of the eyes in shadow and they hide many of the shapes of the eyebrows and the bridge of the nose. Shadows are cast onto the face, both behind the glasses and below them. A close look at eyeglasses will reveal many areas of extreme darks and bright highlights, along with areas and edges that seem to disappear altogether.

One of the most important details is the tiny edge of light that is found around the inside edges of frames and lenses. It is this light that "lifts" the glass away from the face and gives the impression of space between the glasses and the skin. It is subtle, and does not show all the way around, but fades in and out. On the example below, it is most evident around the bottom edge of the glasses and in the upper corners where it stands out against the dark shadows.

When drawing eyeglasses, ask yourself, *where is it light against dark, and dark against light*? Forget what you think glasses look like, or you will end up outlining everything. Instead, take time to study the image closely, and try to imitate all the little details you are seeing.

This close-up shows not only how eyeglasses affect the look of the eye, but how to handle wrinkles and character lines.

Notice how subtle the wrinkles are. They are delicate and irregular. The biggest problem I see with my students drawing wrinkles is that they make them way too dark and harsh looking. Each wrinkle should be addressed individually. The shading plays an important role in how they look. The deepest creases have obvious edges, with reflected light along the edge. Faint pencil lines represent the smaller wrinkles, and help create the "crepe" appearance of older skin.

Wire-rim glasses can be hard to draw because we have a tendency to make them much thicker than they really are. Be careful to watch your shapes for accuracy. Also, because they are metallic and reflect light, the rims seem dark in some areas and light in others.

This profile study shows how complex the details can be and how they affect the features of the face. Glasses are much easier to draw if you try to see them as just patterns of lights and darks, which will give the illusion of reflecting light and the shadows that are cast upon the face.

On this semi-profile, the model's right lens appears light and a little foggy, while the lens on his left is darker, due to the skin behind it.

The frames of the glasses must be studied carefully for their shapes and where they reflect highlights. Notice on these extremely dark frames the ridge of light that appears below the inside edge of the glasses. This small detail is what keeps the glasses looking as if there is some space between them and the face. Look at the shadows they cast onto the face, below the eye on the left and through the eye on the right.

Drawing eyeglasses step by step

Follow along with this step-by-step demo for practice in drawing eyeglasses. This exercise will be a challenge, for it is a profile drawing as well. It takes everything we "remember" about eyes and eyeglasses and distorts it due to the pose.

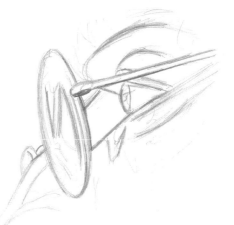

1 ACCURATE LINE DRAWING

Create an accurate line drawing of the eye and eyeglasses. You can freehand it by observing the shapes as puzzle pieces. Look at how each shape connects to the next one, comparing the sizes and angles of each piece.

Or you can place one of your clear acetate grids over this drawing, and use the graphing method for capturing shapes.

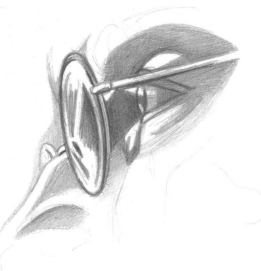

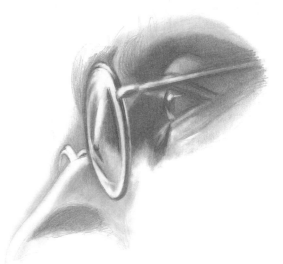

2 APPLICATION OF TONES

Begin by applying the darkest shapes of the drawing with your pencil. Carefully observe the elliptical shapes of the iris and the lens of the glasses. Place the dark tones in as geometric shapes for now. Take your time to accurately depict the ellipses. Allow the dark areas to create the light ones. You can see how the rims of the glasses are created by adding the dark tones on either side of the light areas along the edges. That is how to create the light-colored frames along the face as well.

3 BLENDING

Blend the tones to make them look smooth. Use a kneaded eraser to lift the highlights and reflections. You can see how lifting the light makes the eyeball and the glasses' lens look shiny. It makes the frames look metallic too.

At this stage you can go back and forth, deepening tones for intensity, if needed, and lifting highlights for contrast. There is no limit to how many times you can rework something.

Sunglasses

Drawing sunglasses is similar to drawing regular glasses, but you do not see the eyes as you normally do. Depending upon the type of sunglasses, the lens area can be quite dark, or it can be quite reflective. There is no "normal." It is entirely dependent on the lighting and how much light is reflecting off of them. This creates geometric patterns of light and dark that you will capture in your drawing.

Look at these two examples and you can see how each one of them is different due to the extreme lighting. In the portrait of Ray Charles, the eyeglasses are extremely dark with just a few highlights of the face showing through. The light reflects off the rims in irregular patterns.

The portrait of Robert Redford has different characteristics. His sunglasses have mirrored lenses that reflect the light into bright geometric patterns. Because of the strong light source coming from the upper left, the light illuminates the hair and the upper portion of the sunglasses, with bright highlights

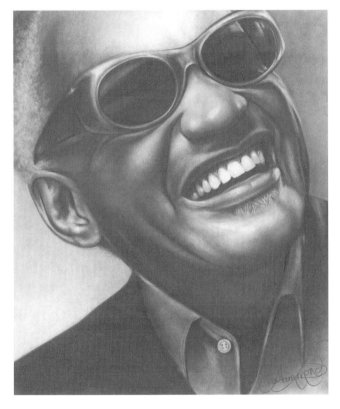

RAY CHARLES
Graphite on smooth bristol • 12" × 10" (30 × 25cm)

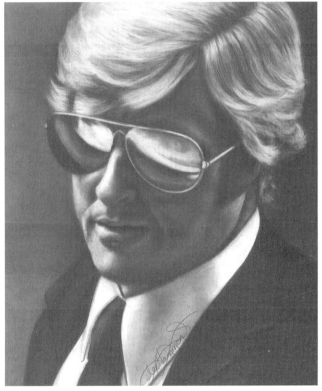

ROBERT REDFORD
Graphite on smooth bristol • 12" × 9" (30 × 23cm)

A finished portrait

This is a typical example of the type of drawing you will be asked to do when you become a portrait artist. This shows how important it is to know how to draw eyeglasses well. It can make or break a portrait.

Because of the pose here, the light affects each lens of the glasses differently. One is see-through like a window, with the eye clearly visible underneath. The other is highly reflective. While the eye is still seen, the right side of the glasses is brightly illuminated and contrasts sharply against the dark background.

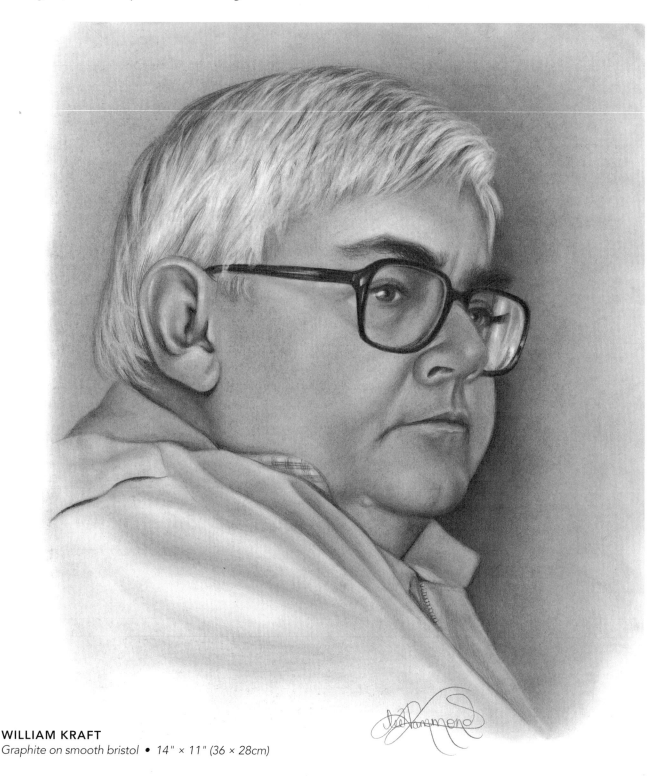

WILLIAM KRAFT
Graphite on smooth bristol • 14" × 11" (36 × 28cm)

Important Points to Remember

1 The eyeball sits "in" the face.

2 There is one eye-width between the eyes.

3 Eyebrows and eyelashes should first be seen as an overall shape.

4 The iris and pupil in the eyes are nature's perfect circles.

5 The perfect circles of the iris and pupil will turn into ellipses when the eye direction is not a straight-on view.

6 Always draw the iris and pupil with a circle template or an ellipse template for accuracy.

7 On a profile the upper eyelid thrust is about a 30-degree angle.

8 Always look for the lower lid thickness.

9 Always reduce the catchlights to one per eye, and place them half in the pupil, half in the iris.

10 If the head is tilted, don't accidently straighten up the eyes. Be sure to have your angles accurate.

11 Eyeglasses should be seen as light and dark patterns.

12 Watch for shadows that are created by the glasses.

13 Look for the rim of light that separates the glasses from the face.

14 Practice!

15 Practice!

16 Practice!

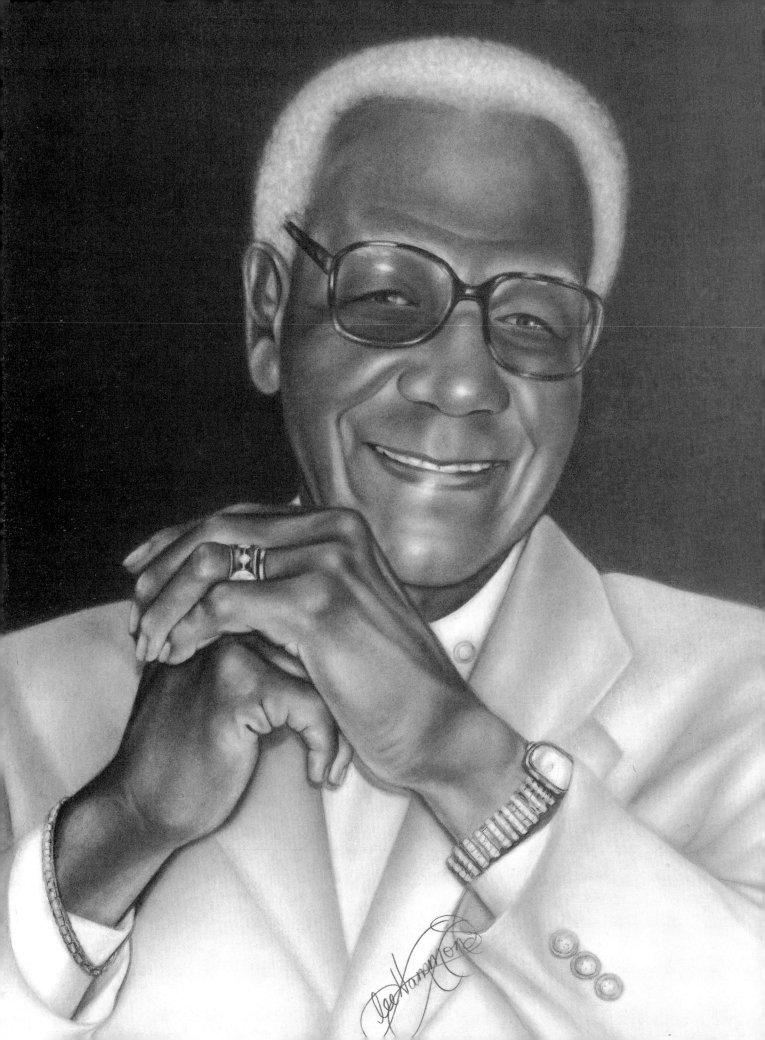

7 Putting It All Together

Now that we have practiced and explored each individual feature, it's time to tackle the entire face. Creating a likeness of someone requires time and patience and the ability to tie all of the individual features together effectively to see the face as a whole. A well-drawn portrait is one that captures and holds your subject's personality, and is well worth the time and effort invested.

Although the eyes were the last feature we studied, they will now become the first area to be rendered. The eyes become your focal point. Here is where your subject's personality will be revealed, and they will lead you, the artist, to the correct size and placement of all the other features.

As you progress through the step-by-step demonstrations in this chapter, refer back to the earlier chapters, refreshing your memory about the small details of each feature as you go.

Don't worry about the hair at this time. It will be covered in depth in the next chapter, and you can come back and finish your work later. Right now, concentrate on just the face. Take your time, practice and do it well.

BUCK O'NEIL
Graphite on smooth bristol • 17" × 14" (43× 36cm)

Correct placement and proportion

In the illustrations below, you can see that the face and head can be divided into equal sections. If you look at the horizontal lines numbered 1, 2 and 3, you will see that line 2 marks the halfway point on the head—from the top of the skull to the bottom of the chin. Students are often surprised to see the eyes as the midway point, and want to place the eyes too high. There is the same amount of distance between the top of the head and the eyes as there is from the eyes to the chin.

Now look at lines 1, 4 and 5. You can see that line 4 is the halfway point. There is the same amount of distance between the eyes and the base of the nose as there is from the base of the nose to the chin. You can also see how the ears line up between lines 5 and 4.

The dotted vertical lines show the relationship of the eyes to the nose, mouth and chin.

Now study the profile. The vertical line through the ear represents the halfway point to the thickness of the head. There is the same amount of distance between the back of the head and the ear as there is between the ear and the front of the cheek bone.

The vertical line in front of the eye shows that even in a profile the middle of the eye lines up with the corner of the mouth. The angled lines show the outward thrusts of the brow bone and the upper lip.

The back of the head is really much shorter from top to bottom than the front. If you draw a line back from the nose and the ear, that is where the base of the skull meets the neck. The neck is not vertical but tilts forward.

Segment drawings

Before you attempt drawing an entire face, which can be a bit scary at the beginning, use a tool I developed for practicing facial features without becoming overwhelmed. Students of mine who do these practice studies always advance much more quickly than those who do not.

This is an example of what I call a "Segment Drawing Notebook." Each square is an individual project, designed for instant gratification and quick progress of your drawing skills. It takes a little time to complete one of these drawings, but the information learned and the practice they provide is invaluable. I suggest doing at least one a day to hone your skills.

The drawings are called "Segment Drawings" because they are created by making a viewfinder, or mini-frame, with black construction paper, and using it to isolate a small segment of a larger photo to practice from. Shown here is a page out of my "Segment Drawing Notebook" and I encourage you to make one of your own. The following page will give you your first assignment.

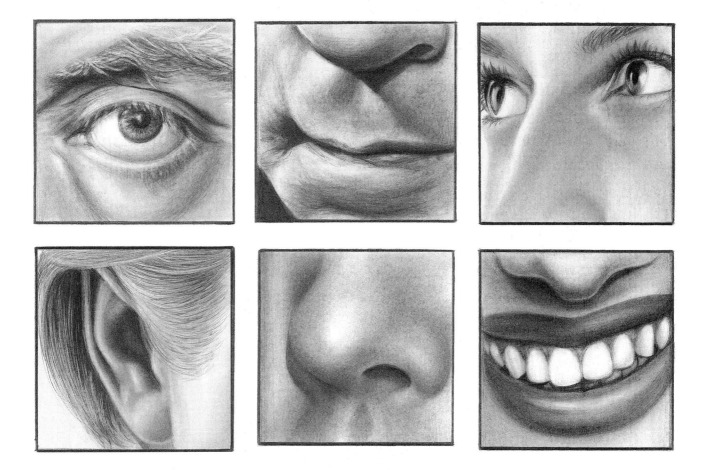

Segment drawing notebook

Follow along with the steps below to create your first entry into your own "Segment Drawing Notebook." First, measure the square around my photo example at right. Then draw a square of the very same size on your drawing paper. Follow the step-by-step instructions for rendering the example.

To create more segment drawings, cut a square opening in a piece of black paper. I recommend making the opening between 2 or 3 inches (5 or 8cm) square. Anything bigger than that includes too much information. The goal is to isolate shapes so they are not as recognizable, making them easier to draw.

Once you have your viewfinder created, use it as a template to draw the squares on your drawing paper. That way you know the squares are identical in shape and size.

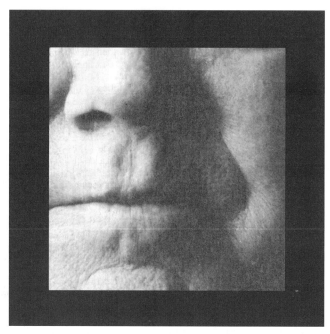

This is what a photo looks like with a viewfinder over it. I use tape to hold it in place so the photo doesn't shift as I work.

1 ACCURATE LINE DRAWING

Freehand an accurate line drawing within the square. Look at where the shapes line up within the square. Look at how far up the mouth is from the bottom of the square, and make a mark. Look at how far down the nose is from the top, and how far over it is from the edge. Make a mark for each measurement. If you are not confident freehanding, divide the box into a grid of four 1-inch (25mm) squares.

2 APPLY TONES

Place the darkest tones of the drawing with your pencil as shown. You can already see the contours and roundness of the facial features being developed.

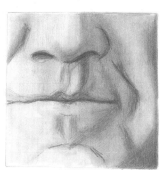

3 BLEND AND DEEPEN TONES

Blend the tones with a tortillon to make them look smooth. When I got to this stage, I could see that my tones were not dark enough; I needed to reapply my tones to deepen them.

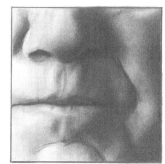

4 BLEND AND HIGHLIGHT

After deepening the tones once more, I blended again. I lifted highlight areas out with a kneaded eraser on the nose, above the lips and in the chin area.

Working from a photograph

Now that you have learned how to draw correctly all of the facial features, it is time to try an entire face. Use this photo reference to create an accurate line drawing of the little girl. This straight-on pose is the easiest to capture for a beginner.

Take your time when creating your accurate line drawing. Be sure to make your grid lines on your drawing paper extremely light. This is not just practice anymore; you are actually creating a portrait, so you do not want to see a "ghost" of the grid in your work.

When you are happy with the results of your line drawing, carefully remove the grid lines with a kneaded eraser and follow along to create the little girl's portrait.

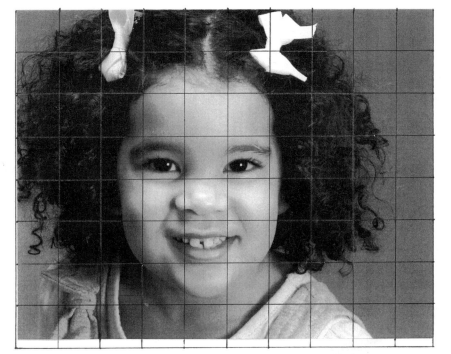

Little Girl with Curls
Use a ½-inch (13mm) grid or larger to create an accurate line drawing of this little girl. As long as your squares are drawn perfectly square on your paper, you can make your drawing as large as you want.

1 ACCURATE LINE DRAWING
This is what your accurate line drawing should look like. Carefully analyze the shapes within each box, remembering the elements of each facial feature as you go. Pay close attention to the teeth. They all must be of perfect shape and size. This is where the grid is very helpful.

When your drawing looks like mine, carefully remove the grid lines from your drawing paper with a kneaded eraser.

Little girl with curls

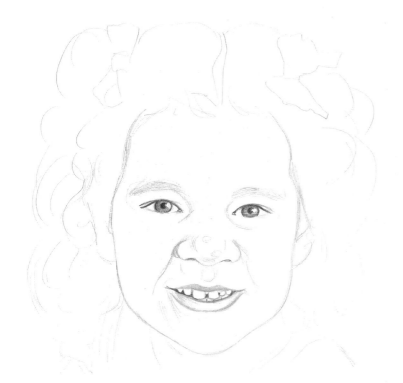

2 THE RENDERING

Start the rendering phase with the eyes. Refer to the original photo for details as you go. Move down to the nose and the mouth, adding the darkest tones with your pencil. This is what I call the "triangle of features." These features are the most important part of the portrait. If they are not accurate, there is no reason to finish the drawing.

Pay particular attention to the mouth and the open smile. Each of her teeth must be accurate in size and shape. Refer to the original photo often, allowing the grid to help you analyze the shape of each tooth.

3 BUILD THE TONES

Continue to build the tones of the face to create roundness and form. Build the depth between the eyes, under the nose and along the side of the face.

To help create the light edges of the face, start placing some of the dark tones of the hair next to it. This helps eliminate the outline created by the accurate line drawing in Step 1.

Place the shadow tones onto the neck and chest area.

We will cover hair in more depth in the next chapter, but you can get a head start (pardon the pun!) with this drawing. Start placing pencil lines in the same direction that the hair is going. If you look at my drawing you can clearly see the direction of each pencil line. Fill yours in until it looks like mine.

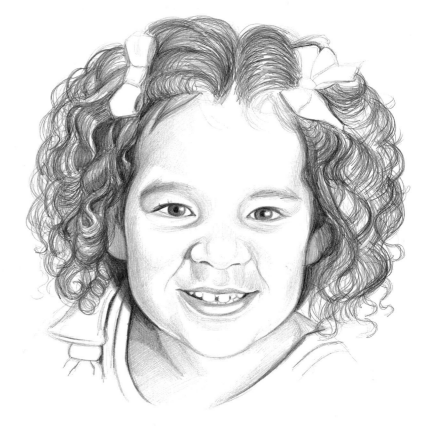

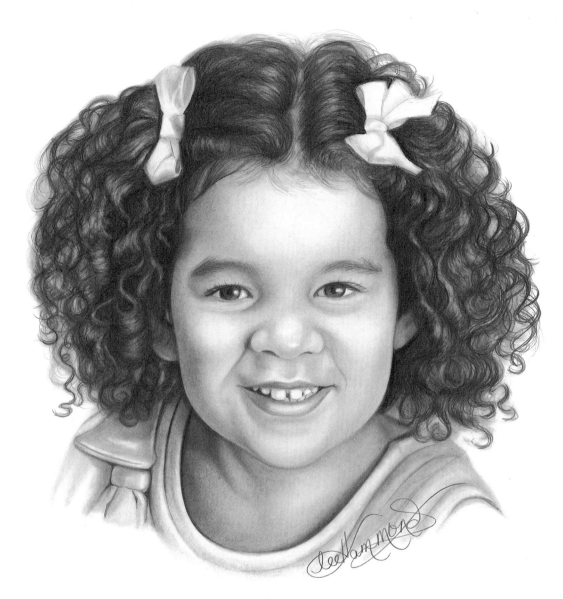

4 BLEND AND HIGHLIGHT

Blend the tones of the face with a tortillon to make the skin look smooth and even. Always blend from dark to light to transition the tones gradually. You can see that the light is coming from the left, so the right side of her face is going to be darker, with the shadows much more evident. Allow the shading to create the form and contours of the face. There is very obvious reflected light along the sides of the face, which helps make her face look pudgy and round. Do not allow your blending to become smudgy or streaky. Her skin tone is very smooth and even. Use a clean tortillon any time you encounter streaking, and be sure to use a light touch that will not rough up the paper as you work.

Blend out the tones of the neck and chest. Be sure to go from dark to light. Notice how the outline of the shirt is not as obvious now, looking more like an edge instead of a line. Shading out from the line into the chest, makes the line appear as a light edge of a shirt resting against her skin.

Continue filling in the hair until it looks dark. Build the tones with the pencil lines mimicking the growth direction of the hair. When you have it good and dark, blend the entire area of the hair with a tortillon to eliminate all of the white of the paper. This makes the hair appear thick and voluminous. Once it's blended, reapply the darkest areas with your pencil. Then lift out the highlight area of each curl with a kneaded eraser. Remember that "lifting" is still drawing! You are drawing in the light. Therefore the light must be lifted going with the hair direction the same way you added the dark.

More hair demonstrations are shown later. Jump ahead and review the process as you work on this project.

Drawing dark skin tones

This photo will give you practice drawing a different pose, gender and skin tone. Every project you encounter will provide you with new elements to learn. It is of the utmost importance to practice drawing as many different faces as you possibly can.

Portrait of a Black Gentleman
Use a ½-inch (13mm) grid or larger to create an accurate line drawing of this gentleman. As long as your squares are drawn perfectly square on your paper, you can make your drawing as large as you want.

1 ACCURATE LINE DRAWING
Draw slowly and create an accurate line drawing. Take time to examine the shapes inside each square as you draw. When your drawing looks like mine, carefully remove the grid lines from your drawing paper with a kneaded eraser.

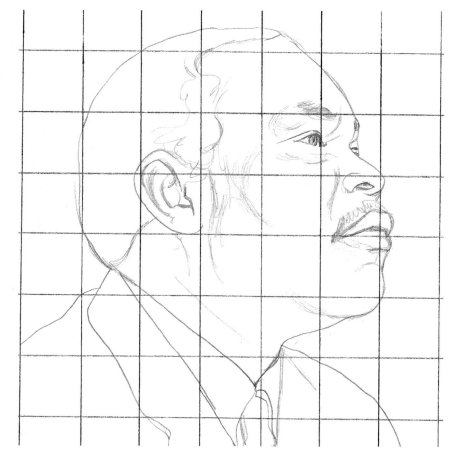

2 THE RENDERING

Study the photograph and my example here, and draw in the triangle of features. When you have the shapes and tones created, lightly blend the tones with a tortillon.

3 BUILD THE TONES AND BLEND

Continue adding the tones to the rest of the face and into the back of the head. Watch for areas of light and dark that help create roundness and form, much like the sphere.

Render the ear. Study the shapes carefully, and refer to the ear chapter if necessary.

Blend everything out, then add the hair. When working the area of the hair, apply the pencil lines to go with the growth direction of the hair. Notice how it curves around the shape of the head.

Add tones to the neck and the shoulder areas of the suit. Blend the tones with a tortillon to make things look smooth and gradual.

Some would be happy with the drawing if we stopped right here, but if you look at my finished example on the next page, you can see how much further it can go.

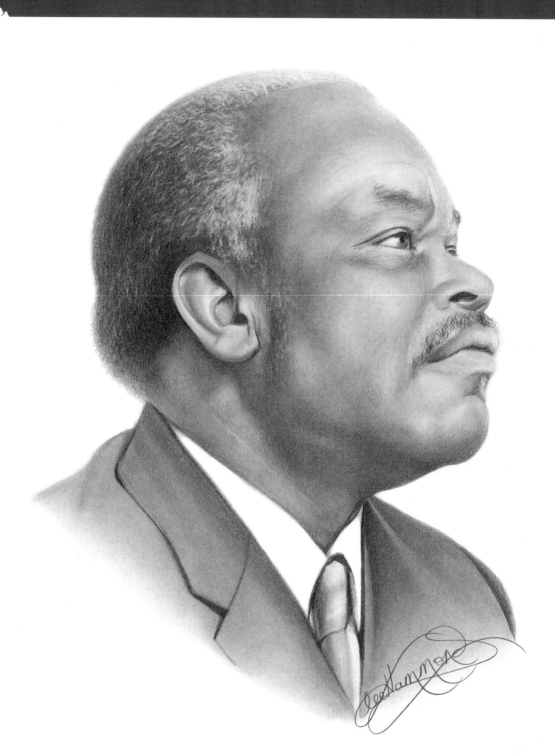

4 DEEPEN TONES AND ADD DETAILS

Study this finished portrait and you can see how much further everything has been developed from the previous stage. I deepened many of the tones to give the drawing more depth and dimension. His complexion looks richer, and the contours of his face are more developed and realistic.

I detailed the hair by adding short irregular pencil lines to create texture and then lifted light hair using the same process. Quick flicks with a kneaded eraser create the look of gray, textured hair. (We will cover this technique in more depth in Chapter 8, "How to Draw Hair.") I used the same process to create the mustache, alternating short pencil lines with quick lifts from the kneaded eraser.

I deepened the tones of the suit and blended out to make it appear smooth. Be sure to add the cast shadows under the lapels to make them look dimensional, not just like pencil lines.

Finally, I added tones to the necktie and lifted the light highlight areas of the tie with the kneaded eraser.

Drawing a cowboy

This photograph will teach you some new elements and give you practice adding special effects into your work. The addition of the cowboy hat, the facial stubble, and the background make this a challenging piece. Take your time and follow along.

The original photo is a very clear black and white photograph that is great to work from. To place a grid over it, I had it enlarged to make the shapes easier to see. By doing this, some of the details were lost, so I decided to use both images: one to graph, and the other to study as I did the rendering. You may often find yourself in this predicament. It's important to always have a good photo to work from. You can only reproduce and draw what you can actually see!

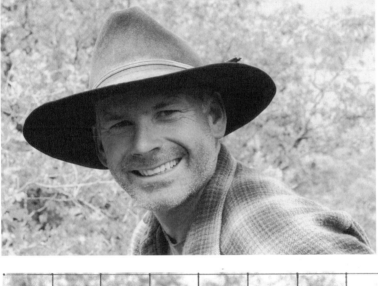

Portrait of JJ Burch
This is a good example of a clear, black-and-white photo. It is perfect for drawing from.

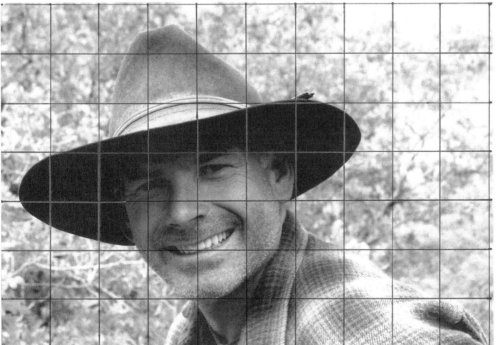

This is a photocopy of the original photograph. While it is fine for graphing, some of the details got darker and harder to see. Use this gridded photocopy to capture your shapes, and use the original photo above to see the details with clarity.

Drawing a cowboy

1 ACCURATE LINE DRAWING
This is what your accurate line drawing should look like. Carefully analyze and study the shapes within each of the squares. Pay particular attention to the mouth and teeth. Always look at where things line up within the box, asking yourself, "How far over, how far up?" as you go along. Each tooth must be drawn accurately for shape, placement and size. Continue drawing as accurately as possible within each box until your drawing looks like mine.

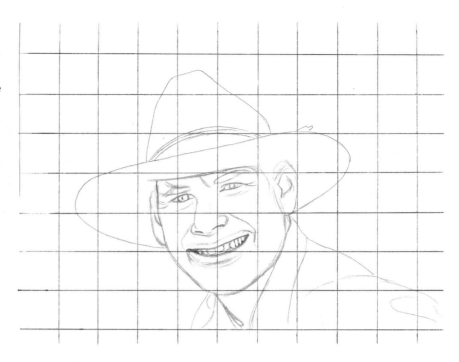

2 THE RENDERING
Once you are sure of your accurate line drawing, carefully remove your grid lines with the kneaded eraser. Then carefully redraw your shapes once more for accuracy. Because of the lines of the grid on the photo, some of the details of the teeth were hard to see. This is your chance to re-analyze the shape of each tooth and draw them in with more detail.

Begin to add some of the tones into the face and neck to create the contours and shadow areas.

Render the eyes and fill in the eyebrows. Because this is a smaller drawing, you do not see as much small detail as with some of the other drawings we have done so far. It is the overall shape that is crucial. Be as accurate as possible.

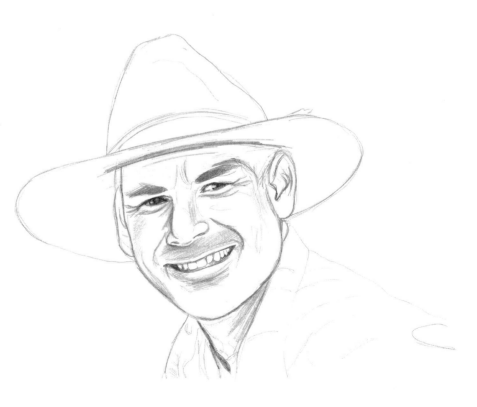

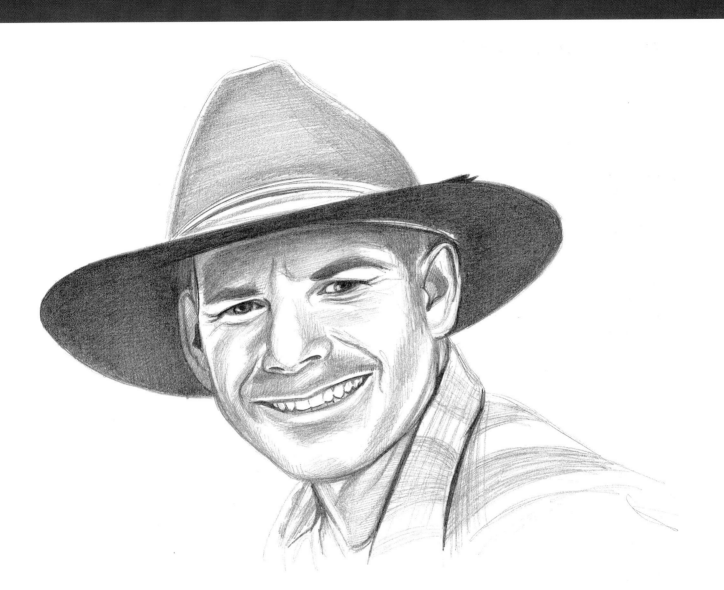

3 BUILD THE TONES

Add the tones to the hat for contrast. The inside of the hat's brim is the darkest part of the entire drawing, and it will give you something to compare your tones to as you draw. The upper part of the hat is much lighter due to the light source.

Deepen the tones on the face to give it more depth. You can see how the hat is casting a shadow onto the forehead. Study the original photograph to see the details here more accurately.

Once the tones have been deepened, you can really see the patterns of light and dark being developed on the face. Already, his face is looking more realistic.

We will cover how to draw fabric and clothing in Chapter 9. For now, use pencil lines to represent the pattern of his shirt. Make the lines curve to match the roundness and flow of the shirt over his neck and shoulders.

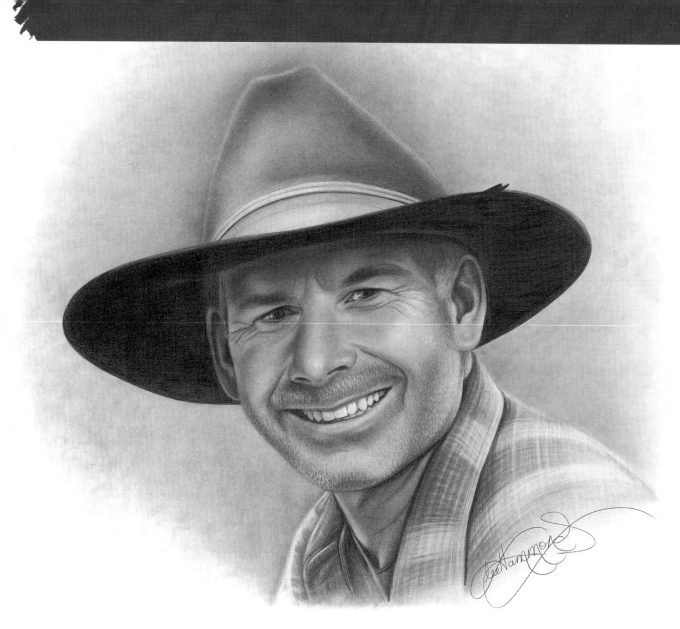

4 DEEPEN TONES AND ADD DETAILS

To finish the drawing, all of the tones must be deepened. Once they look accurate, gently blend everything out until it appears smooth.

To create the look of whiskers and stubble, use a combination of very quick strokes with the pencil, and then quick lifts with a kneaded eraser. Squish the eraser into a thin razor edge with your thumb and forefinger, then use very light "flicks" to lift the tiny white hairs out of the shading. You can lift only two or three times before you have to fold over the eraser and get a new edge to it.

I used a similar process to create the plaid pattern in his shirt. It's nothing more than a combination of pencil lines, blending, then lifting light lines out with the eraser. This process is repeated until you get the results you like.

The background of the drawing is what really finishes it off. I placed pencil lines into the background with circular motions until it somewhat filled in, then blended it out with a very dirty tortillon until it looked smoother. The goal is not to make it perfectly even, but to allow the swirly strokes to still show. This gives it an illusion of nature behind him, without showing details. It places him into focus.

Work on your drawing until it looks like this. Look for subtleties such as:

1 Reflected light along the edge of the hat and hat bands.

2 The shading of each tooth, and the highlights lifted out for shine.

3 The laugh lines around the eyes. Don't overdo them!

4 The facial hair. Look for the patterns of light and dark, and alternate using your pencil and eraser.

5 The plaid shirt. Make sure the patterns "bend" with the curve of the shirt. Lift reflected light along the edges.

Important Points to Remember

1. Study the facial diagrams and memorize the general placement of the features. Remember the size relationships and measurements, and how the head and face can be divided into equal distances. Refer to page 94 for feature placements.

2. Work from a photo that is large enough so you can see the details clearly.

3. Start your portraits with an accurate line drawing.

4. Begin your rendering with the eyes and work them to completion before moving on to the other features. Move down to the nose and mouth, which is called the "triangle of features." Then continue with the dark side of the face.

5. Make an artistic statement; do not merely reproduce the photo.

6. Practice!

7. Practice!

8. Practice!

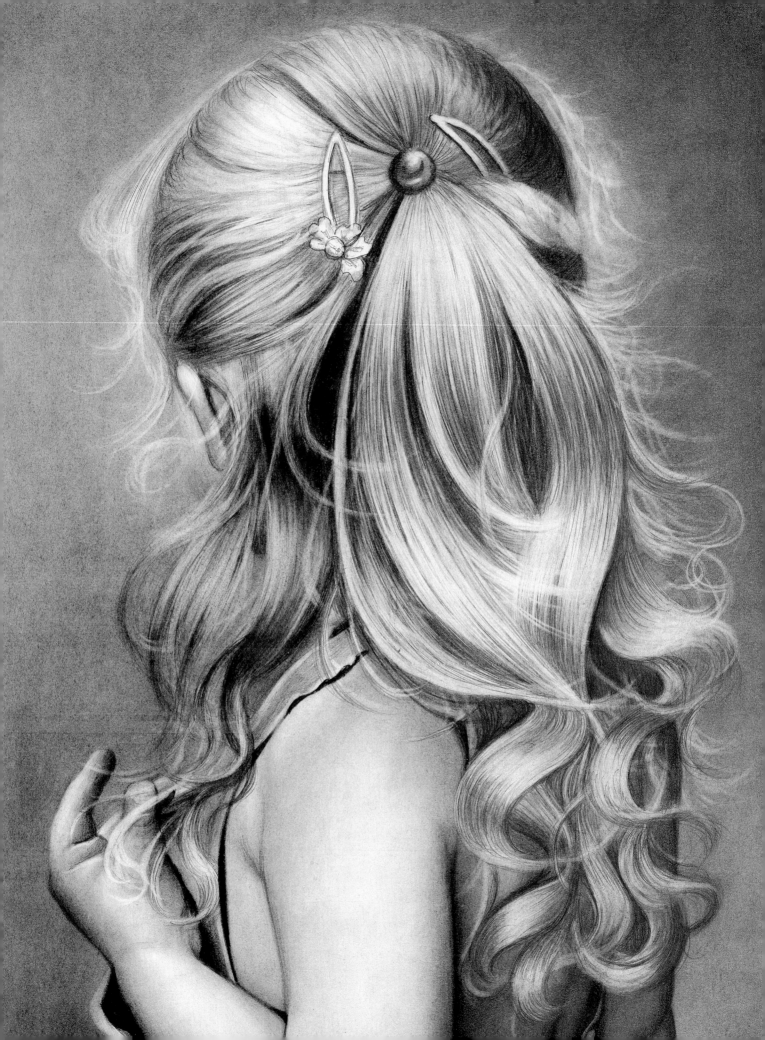

8 | How to Draw Hair

Of all the features we've studied so far, the hair will require the most patience from you. It's not that the hair is necessarily that much harder; it just demands a lot more time to make it look real. The time required to draw the hair convincingly can sometimes be three to four times the amount it took to draw the entire face. Because the face is the focal point, we have a tendency to think of the hair as the last step, the quick final touch before the portrait is done. It may be one of the final steps, but it is hardly quick.

In the following pages, I have tried to give you a sampling of as many hair types and styles as possible. By practicing with these examples, you should be able to handle any hairstyle that will come your way. A good source of practice material can be found in hairstyling magazines. Their illustrations are wonderful for practicing the face and hair, especially because they are often printed in black and white.

Do not let the full head of hair at left intimidate you. By following the three-step process and devoting the time required, you will find that drawing hair can be a fun, rewarding challenge!

PORTRAIT OF CAYLA
Graphite on smooth bristol • 17" × 14" (43 × 36cm)

Drawing the hair step by step

Like anything else, we'll begin the hair with a line drawing. Look at the hair first as a solid shape, drawing its outside dimensions. The details of the hair will be built up slowly in layers.

Start applying the dark tones of the hair by laying in tone in the direction the hair is growing. Don't try to imitate hair strands with pencil lines at this stage. Just concentrate on filling in, and establishing the light and dark patterns.

Once the darks have been placed, blend them out to a halftone. Reapply your darks by drawing the darks into the light area. On the example shown here, draw from the bangs into the light area, and from the base of the ponytail up into the light area. This light area, which follows the round contour of the head, is called the *band of light*.

Now, pull the light area into the dark with the sharpened point of your kneaded eraser, much as we did with the eyebrows and facial hair in earlier chapters.

Repeat the three-step process of applying the darks, blending the tones into one another and picking out the highlights until the volume builds up and gives you the fullness that you need. Don't stop too soon! It will take a while to create the right balance.

Curly or wavy hair is done very much the same way as straight hair. The difference is that each curl or wave has its own set of lights and darks that must be drawn independently, and then blended into the others.

Never try to create the light areas of the hair by leaving the white of the paper showing and drawing around it. The highlights on the hair are actually the light reflecting off the top, outside layers of the hair. If you just leave these layers out, it looks as if you are seeing through the hair. You must lay in your tone, blend everything out, and lift the highlights out with the eraser. This keeps the light on the outside layers where it belongs and softens the pencil lines, creating a gradual transition from dark to light.

1 DRAW THE SHAPE
Draw the hair as a solid, overall shape in your line drawing.

2 ADD TONE
Draw your dark areas into the light areas to create the "band of light." Blend it out to a smooth tone.

3 BLEND AND LIFT HIGHLIGHTS
Reapply the darks, blend again, and lift the highlight areas with your eraser. Build the hair up in layers until you are satisfied. Let some of the pencil lines resemble hair strands on top of the blending. With your tortillon, gently soften the outside edges of the hair, all the way around, to keep it from looking hard.

Finding the "band of light"

These three examples show how different the hair appears when styled uniquely. In each one, there is a definite "band of light." But the band of light appears in different places depending on the hairstyle, and where the curve of the hair is most obvious.

This hairstyle is very similar to the one on the previous page, but the hair color is much darker. Look at how the "band of light" shows in both the back of the head, and in the curls of the ponytail.

When the hair is pulled up onto the top of the head, the roundness of the head underneath causes the hair to bulge. The circumference of the head is repeated in the shape of the hair. Look at how the "band of light" circles both the head and the hair twisted on the top of the head.

When the hair is down, the "band of light" is still visible, and it repeats anywhere the hair is curved. Each curl and layer of the hair has its own elements of light and dark to deal with.

Light, toddler's hair

To help you understand the time consuming procedure of drawing hair, we can revisit some of the portraits in the book. The following exercise will give you practice and help you understand how each hair type is successfully rendered.

This is a project based on the portrait seen on page 26. The fine, light-colored baby hair must look soft and not too heavy, unlike that of an adult.

1 DRAW THE SHAPE
Start with a basic outline of the head and hair shape. Use some pencil lines to identify the direction of the hair in all of the various areas. Be sure to curve your pencil lines to create the wave of the hair and the contour of the head.

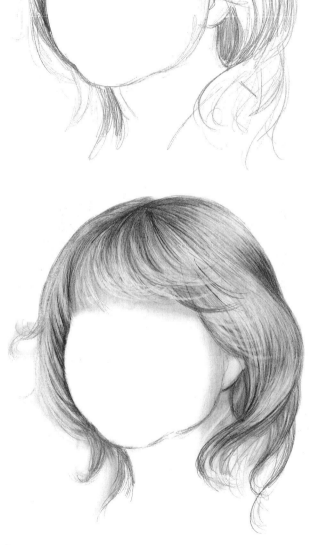

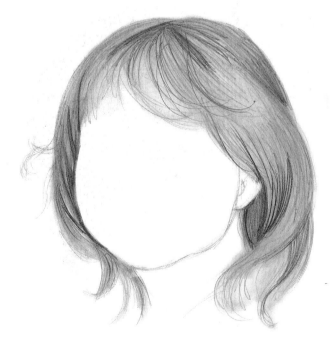

2 ADD TONE AND BLEND
Continue adding pencil strokes to build up the volume of the hair. Make the areas next to the face and in the part the darkest. Use a tortillon and blend the entire area out to get rid of the white of the paper.

3 LIFT HIGHLIGHTS
Use a kneaded eraser to lift highlights out of the hair, and to add the wispy hairs cutting across the forehead. See how the light hairs overlap the darker ones? To make hair look real, it must have a multitude of obvious layers.

Short, dark hair

Drawing this type of hair is basically the easiest. There are no large curves to deal with or obvious areas of extreme lighting. But this does not mean that it's not time consuming. Creating the look of the thickness of this hair requires many, many layers of applied pencil lines.

This hair is seen on the portrait of Christopher on page 52.

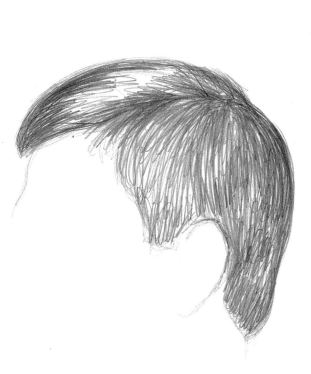

1 DRAW THE SHAPE

Start by drawing in the basic shape of the head and hairline. With short, quick strokes, apply pencil lines to start filling in the area of the hair. Remember that the length of the pencil strokes represents the length of the hair. Follow the direction that the hair is growing, making the tones darker in the area of the part.

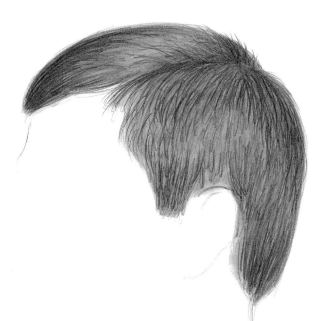

2 ADD TONE AND BLEND

Continue adding pencil strokes to build up the depth of the hair. Blend everything out with a kneaded eraser to remove all the white of the paper.

3 LIFT HIGHLIGHTS

Finish the hair by adding more and more pencil strokes to build up the volume. Look for areas that are clearly darker and focus there. When the depth of layers has been achieved, lift some lighter hairs with a kneaded eraser. Use fast, quick "flicks" with the eraser to create the reflected light and the look of layers. If you pull too much out, simply reapply your pencil lines on either side of the light area to narrow it down. Remember, using the kneaded eraser takes a lot of practice!

Dark, tightly curled hair

This is the hair seen on the portrait on page 54. The tight curls and soft appearance is not as difficult as it looks. It still requires some time, though.

1 DRAW THE SHAPE

When hair is fairly thin, allowing the skin to show through, it's very important to develop the skin tone underneath first. You never want to apply the hair, no matter how well you do it, over the blank white of the paper. Skin tone must be evident underneath. Start the drawing by creating the basic shape of the head first. Then begin shading in the skin tones. Here the shape of the head is seen through the hair. I applied the darkness along the edge of her scalp and then created a secondary line above it where the edge of the hair will be.

2 ADD PENCIL STROKES AND BLEND

Start drawing in the hair with very small, circular strokes, like curlicues. Continue these strokes making them darker and fuller along the back of the head. Continue across the top of the scalp. Blend these strokes out, particularly above the head. This makes the hair look fuzzy.

3 CONTINUE ADDING PENCIL STROKES

You can see how much darker the hair is in this final step. This is done with repetitive applications of the curlicue strokes and firm pressure on the pencil. Where the hair is thinner and more wispy, use less pressure on the pencil. Look at the hair on the outside edge and you can see how delicate the little curly strokes are.

Light, fuzzy hair

This hair is from the portrait seen on page 92. It is similar in approach to the hair of the little African girl on the previous page, but this time the hair is extremely light instead of extremely dark.

1 DRAW THE SHAPE
Start the drawing with the overall shape of the head and hairline.

2 ADD TONE AND BLEND
Since this hair has turned white, we need to add some background tone to help describe the edge of the hair. We also need to add some of the skin tone underneath and below the hair to create the edge of the hairline. Once those darker tones are added, begin the hair using the small curlicue pencil strokes as shown. With the tortillon, lightly blend out the hair area to remove the white of the paper. Even though the hair is white, all of the white areas need to be "lifted," not left empty. This is what makes the light look as if it is on the outer surface of the hair, not as if you are looking through it to the paper.

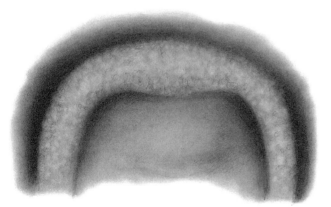

3 LIFT THE LIGHT AREAS
Continue the process of adding small, curly strokes and lightly blending. Lift the light areas of the hair with the kneaded eraser. For this fuzzy type of hair, you can actually use a dabbing process with the eraser to lift the highlights. Notice how the light is mostly in the middle area. It is a little darker along the hair line, and along the edge where the dark of the background is coming through.

Long, adult hair

This hair is shown in the portrait on page 14. As you can see, it is similar to the project on page 112, but this hair is much longer and thicker. It requires a lot more layers and longer pencil strokes.

1 DRAW THE SHAPE
Start the drawing with the overall shape of the head and hair. Start the curves of the hair with long, curved pencil lines. The length of the pencil lines will replicate the length of the hair.

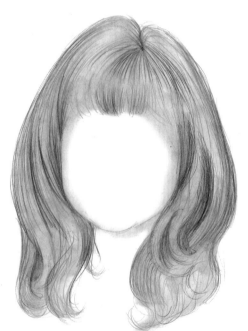

2 ADD LONG CURVED STROKES AND BLEND
Continue adding long, curved strokes to build up the volume of the hair. This is the time to divide the hair mass into various layers. Look at the area of the bangs, and you can see how the "band of light" has been created. Draw the darker areas first, and allow the middle area to remain lighter. To do this, come down from the part and stop the stroke midway. Then come up from the bottom of the bangs and stop before you touch the pencil strokes already applied. Blend all of the hair out with the tortillon to remove all the white of the paper.

3 LIFT HIGHLIGHTS
Continue building the volume of the hair with more and more strokes. Always note the direction the hair is going and use curved, long strokes to create it. Look at the areas of overlap and layers, and make the darker areas stand out. Lift the highlight areas out with a kneaded eraser, using the same quick, curved strokes you used with the pencil. Look where the light hairs overlap the dark areas to create the curls. Create the band of light in the bangs by lifting the highlight running across the middle of them. Use the kneaded eraser and quick strokes.

Braided hair

Even when hair is braided, the "band of light" is clearly visible. Let's draw a braid together.

1 DRAW THE SHAPES
Start by drawing in the shapes in line form.

2 ADD DARKER STROKES
Begin adding the dark areas of the braid. Use pencil strokes that replicate the direction that the hair is going in each segment. The pencil lines will create the texture of the hair strands.

3 BLEND THEN LIFT HIGHLIGHTS
Build up the amount of pencil lines to give the hair volume. Hair is thick, and it requires a lot of pencil lines to give the illusion of thousands of hair strands.

When you have enough pencil lines to make the hair look believable, blend it all out. You must remove all of the white of the paper. Blending helps make the hair look full.

Place some shading behind the braid on the left to make it appear as if it is lying against something. To create the "band of light," carefully lift the highlights on each segment using a kneaded eraser. Think of this process as "drawing in the light" rather than erasing. It makes the light appear as if it is reflecting off the outer surface of the hair.

A character study

This is one of my favorite pieces. It is a wonderful collection of everything we have covered so far, all wrapped up into one beautiful drawing. This is much more than just a portrait. The thoughtful gaze and meaningful expression turns this into a character study instead. A portrait will tell you what a person looks like. A character study tells you more; it lends you some insight into what the person is thinking or feeling.

I love the hair in this one. It is obviously quite coarse. To create the wiry strands of the hair, the kneaded eraser was too weak and flimsy. Instead, I used a pen-like stick eraser to draw out the heaviest light strands of the hair, which makes them stand out. (The edge of a Pink Pearl eraser works well for this too.) The smaller light strands were done as usual with the kneaded eraser.

Study this drawing closely and use it to review things such as eyeglasses, wrinkles, and the five elements of shading. You can even see the sphere exercise repeated in each of her earrings!

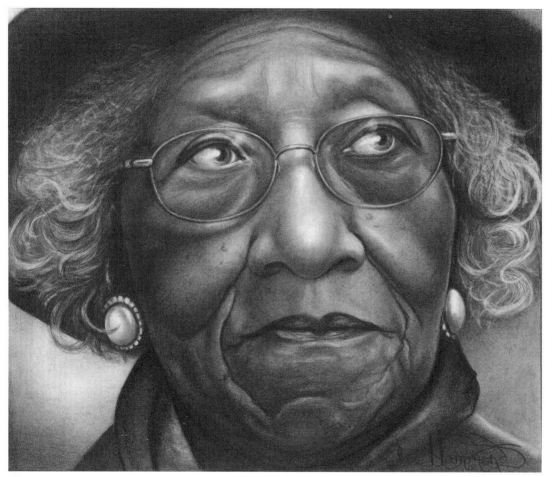

PORTRAIT OF JOHNNIE CARR, CIVIL RIGHTS ACTIVIST
Graphite on smooth bristol • 11" × 14" (28 × 36cm)

Note: When I was working on this drawing, I was on an airplane returning home from Florida where I had been teaching that week. Next to me was a wonderful, nine-year-old boy named Jacob Ponder who seemed to share an interest in drawing. I gave him one of my mechanical pencils and showed him how to use it. I let him help me fill in the tone of her hat, so he could have a part in creating this drawing. I also gave him a piece of my kneaded eraser and showed him how to "lift" light areas. He helped me lift some of the light strands out of her hair. We spent the rest of the flight drawing together, and he helped make a usually long and tiring trip quite fun. Thank you, Jacob, for your help!

Important Points to Remember

1 In the beginning, draw the hair as one solid shape.

2 Start with the darks, laying in tone in the direction that the hair is growing.

3 Always blend out the entire mass and build from there.

4 Each curl or wave has its own set of lights and darks, creating a band of light on each curl or area that curves outward.

5 Hair must be built up in layers.

6 Even permed or frizzy hair should be drawn in the direction of the hair growth. Use tight, circular strokes if necessary.

7 A band of light will be evident where the hair curves around the shape of the head.

8 Even white or gray hair is blended out, with the highlights lifted with the kneaded eraser.

9 The color of hair will be represented by the shades of gray that you use.

10 Practice!

11 Practice!

12 Practice!

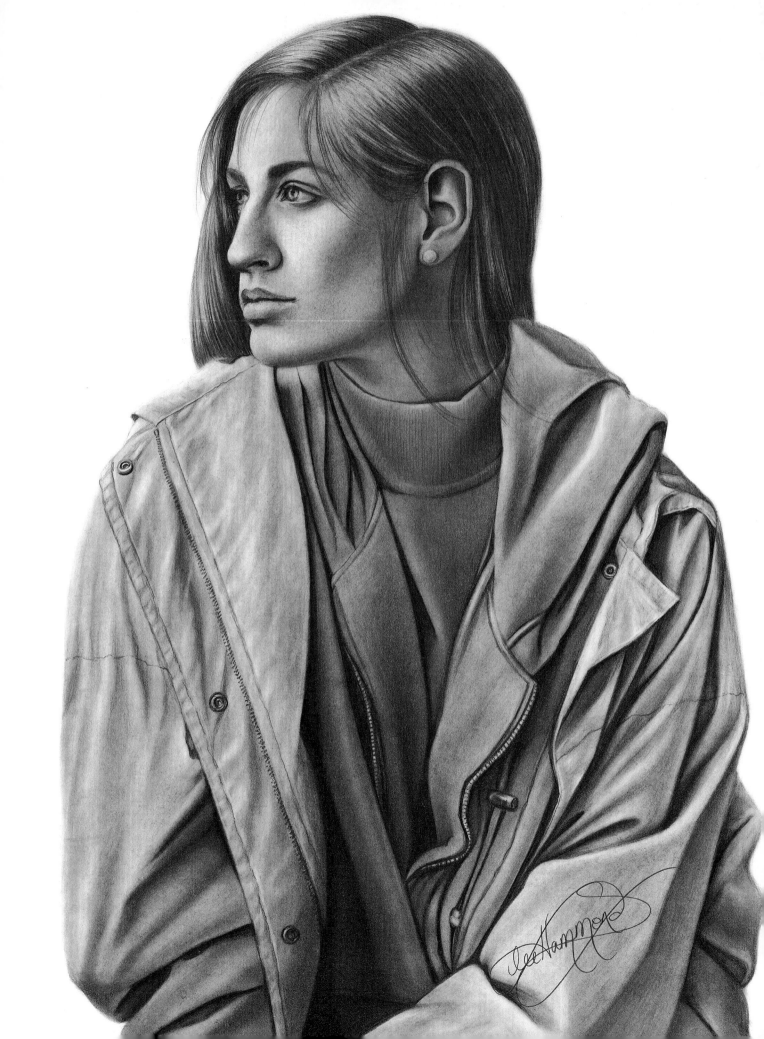

9 How to Draw Clothing

Clothing can be a beautiful thing to draw. The combination of light and dark patterns created by the creases and folds gives the artist another unique challenge. Sometimes it is actually the clothing that makes the portrait interesting; it doesn't always have to be plain and simple. I chose the example at left because of the interesting folds and creases of the shirt and the effects of shadows on them.

It's important to watch closely for the area of reflected light on the creases and folds. The shadow edges in conjunction with the reflected light is what makes the fabric come to life. Look for hard edges where the fabric overlaps. Soft edges are created where the fabric gently rolls.

The following pages explain the various types of folds and how to recognize them and, most importantly, how to use them to enhance the portrait you are working on.

THE WINDBREAKER
Graphite on smooth bristol • 17" × 14" (43 × 36cm)

The five basic folds

There are five basic folds to look for when drawing fabric and clothing, each with its own set of characteristics. The following examples explain each of these folds and how you can recognize them.

A good understanding of folds is necessary to achieve realism in the clothing and to keep the clothing from looking flat, as if it were painted on the subject.

Inert Fold
This fabric is not suspended at all and is "inactive," creating what is called an inert fold. Since the fabric is not suspended and hanging, the folds may go in many different directions. This can be seen when a person is sitting and the fabric of their clothing is resting on the surface that they are sitting on.

Tubular Fold
A tubular, or column, fold is the most common of all of them. You can recognize it by the cylindrical folds that hang from one point of suspension. It can be found in clothing such as scarves, skirts and dresses.

Drape Fold
A drape fold is created when fabric is suspended from two points. It can be found in clothing such as blouses or cowl-neck shirts.

Coil Fold
Any fabric that wraps around a tubular shape, such as an arm or a leg, is called a coil fold. It creates a spiral appearance and can be found in sleeves and pant legs.

Interlocking Folds
Sometimes fabric will create folds that are in layers that actually sit inside one another. These are called interlocking folds and are mostly seen when fabric is wrapped around areas like the neck. This is a good example of how the pattern of the fabric should be carefully observed and followed in and out of every layer, with shadows applied over them.

Combinations of Folds
This illustration shows how fabric can create more than one type of fold at a time. This shoulder contains both interlocking and coil folds. Pay attention to where fabric is pulled or stressed, and look for the light and dark patterns created by the light source. The dark background helps create the light on the top of the shoulder.

Clothing tells a story

You can see by these illustrations how much impact clothing can have on your artwork. The drawing of my grandson, Colin, would not be nearly as eye-catching if it weren't for his little striped shirt! While a baby is always an appealing subject for portraiture, the clothing can add an artistic element that makes it go from cute to awesome!

The clothing can also make a serious statement, as seen in the portrait of an African woman. Her printed clothing and headdress gives the portrait a classy appearance and helps describe the heritage of the woman. Sometimes the patterns or prints of clothing can compete with the subject in a drawing, and I recommend eliminating them if that's the case. But in a drawing like this, the clothing helps tell a story and becomes a key focal point.

Look at both of these drawings and the way the patterns go in and out of the creases and folds of the fabrics. Learning how to draw complicated patterns is the key to making clothing look believable in your artwork.

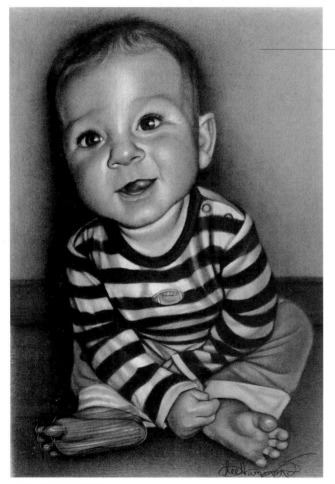

COLIN MARTIN
Graphite on smooth bristol • 16" × 12" (41 × 30cm)

A WOMAN IN AFRICA
Graphite on smooth bristol • 16" × 12" (41 × 30cm)
Art created from a photo provided by Kristen Jaloszynski

Drawing fabric folds

The following exercises will aid you in learning how to draw fabrics of all kinds. Review the information about the five types of folds and the five elements of shading before you begin. All of that is essential to drawing fabric well.

Let's begin with the tubular fold shown on page 122.

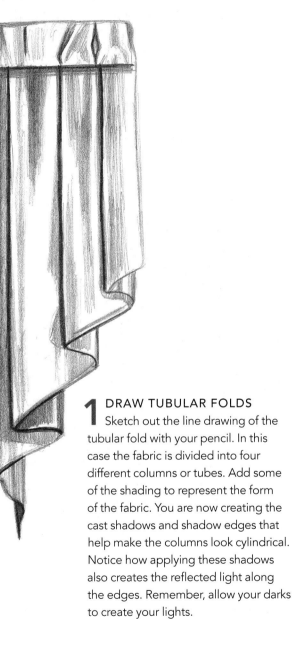

1 DRAW TUBULAR FOLDS
Sketch out the line drawing of the tubular fold with your pencil. In this case the fabric is divided into four different columns or tubes. Add some of the shading to represent the form of the fabric. You are now creating the cast shadows and shadow edges that help make the columns look cylindrical. Notice how applying these shadows also creates the reflected light along the edges. Remember, allow your darks to create your lights.

2 BLEND TONES
Blend the tones with a tortillon until they appear smooth and even. Lift some light along the edges with a kneaded eraser.

Drawing folds and patterns

I created the exercises on these two pages to help you learn how to draw both folds and patterns together. To do this, I took a striped washcloth and positioned it into different folds. I then took pictures of it to put in this book. You could do the same thing and draw from life. Find a shirt or towel with patterns and position it into interesting shapes to draw. It is wonderful practice!

1 DRAW THE SHAPES
Carefully draw this washcloth freehand. This is another example of a tubular, or column, fold. Start with the overall shape and then add the stripes. This will help you avoid becoming confused by so many lines.

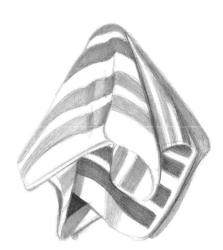

2 APPLY TONES
With your pencil, apply some tones to the stripes. Some of them are lighter than others, so do not make them all look the same. Look carefully and you can see how the stripes are interrupted by the creases of the fabric. They also bend with the curves. Place the cast shadow along the right side. The lighting is not too extreme here, but the cast shadow on the right tells you that the light is coming from the left.

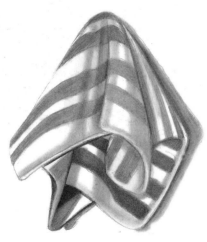

3 BLEND
With a tortillon, carefully blend the tones. This is where you must concentrate on the five elements of shading and the way the shading creates form. Each column has shadow edges to make it look cylindrical. Study my example carefully and do one area at a time. Look at how the shadows go over the patterns of the fabric.

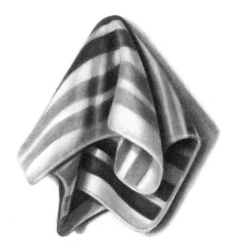

4 DEEPEN SOME TONES
Deepen some of the tones. By getting things a bit darker, the drawing takes on a more realistic appearance. Pay particular attention to the depth of tone in the cast shadows. This is what separates the columns and gives the drawing a three-dimensional look.

This exercise is an example of an inert fold. It is the same washcloth lying on the floor, and it is now a tangle of shapes and patterns. Follow along with the steps to create this drawing.

1 DRAW THE SHAPES
Create an accurate line drawing of the washcloth with your pencil. Because of the many creases and folds, the patterns can be a bit confusing. Try simplifying it by drawing one small area at a time.

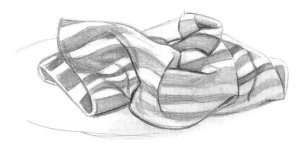

2 APPLY TONES
Add some tone to the stripes of the washcloth. Remember, the stripes are not the same; some are darker than others. Watch how the stripes go in and out of the fabric's folds.

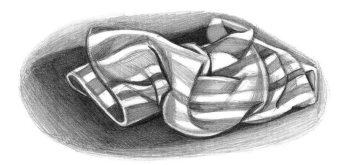

3 DEEPEN TONES AND ADD CAST SHADOWS
Continue deepening the tones of the drawing to create the contours of the fabric. Look for areas of cast shadows where the cloth is overlapping, and areas with shadow edges where the fabric is gently curving.

Add the cast shadow below the washcloth and the tone surrounding it. This makes the washcloth appear as if it is actually lying on the floor and not hovering in space.

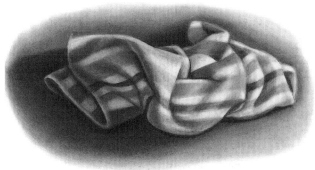

4 BLEND
Blend the tones with a tortillon to make them look smooth. Look at how the three-dimensional effect is created with the shading. Look for areas of deep shadow and bright highlights. You can see that the light source on this one is coming from the right by where the shadows fall.

Extreme lighting on fabric

Not all fabric will have multiple patterns to follow. But sometimes the texture of the fabric and the way it is bending will cause an interesting display of shapes. This leather jacket is shiny by nature and reflects a lot of light. The bright light coming from the top combined with the bend of the arm makes this a good example of deep folds. Follow along to draw this example of a coil fold.

1 DRAW THE CREASES AND FOLDS
Draw the sleeve of the jacket and the patterns of the creases and folds. To establish where the actual bends of the fabric are, place some tone into the darker shadow areas. The light is clearly coming from the top here, so the darkest areas will be deep inside the folds and underneath. Because of the sharp creases, there are many areas with hard edges rather than the soft edges we saw in the previous exercise.

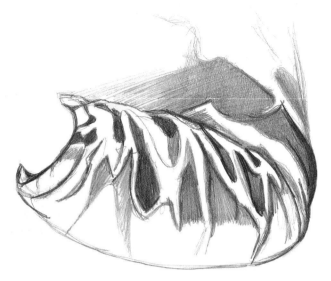

2 DEEPEN THE TONES
Continue to deepen the tones of the sleeve to make it appear like dark leather. Deepen the hard edges and create extreme creases where the sleeve bends.

3 BLEND TONES AND LIFT HIGHLIGHTS
Blend the tones with a tortillon to give it the appearance of smooth, shiny leather. Deepen the tones once more, if necessary, to make it as dark as you need. Lift the reflective light along all of the creases with a kneaded eraser.

Common necklines

Here are some of the most popular necklines seen in portraiture. They are fairly easy to draw and are good when you are not including an entire outfit with your drawing but rather fading it out to concentrate on just the head and shoulders. While these necklines may be simplistic, they must still be realistic. I have seen many good portraits fall short because the clothing has not been done as well as the face.

T-Shirt or Crew Neck

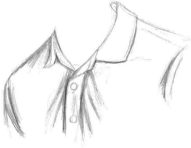

1 DRAW THE SHAPES
A typical T-shirt or crew neck is the most popular neckline in portrait drawing. After the overall shapes have been drawn in, the shadow areas are lightly added in with the pencil.

2 ADD TONES AND BLEND
Blend the tones with a tortillon to make them look smooth. The fabric needs to look like it is gently rolling, not creasing. The only areas that are hard edges in this shirt are in the shoulder seams, between the sleeve and chest area, and along the neckline where the shirt overlaps the skin. The neckline must look like an edge, not an outline. You must shade out from the lines to create edges.

Polo Shirt

1 DRAW THE SHAPES
The polo shirt with a collar is another typical neckline often seen in portrait drawing. Lightly draw the shapes of the shirt and collar with your pencil. Notice how the fabric is pulling at the placket where the buttons are.

2 ADD TONES AND BLEND
Add the tones of the shirt and blend with a tortillon. Deepen the tones in the creases and underneath the collar. Remember to create edges, not outlines. Add the shadow to the skin of the neck. Lift areas of reflected light along the edge of the collar and down the edge of the placket. Do not just outline the buttons! Place small cast shadows where they overlap the fabric, and add small dots inside them to look like thread.

Jacket and Tie

1 DRAW THE SHAPES
The jacket and tie is the third most popular neckline in portraiture. It has a polished, pressed look. It's important that the edges do not appear as outlines. Once the overall shapes have been drawn, apply some of the tones to the shadow areas as shown.

2 ADD TONES AND BLEND
Apply tones to the jacket and tie. Blend with a tortillon to make them look smooth. Place cast shadows underneath the lapels to separate the two surfaces. Lift the reflected light along the edges of the lapels. Apply some shading to the white dress shirt to give it dimension. Lift some reflected light along the edges of the neck and the collars. Apply shading into the background to help create the light edges along the shoulders.

Finished portrait

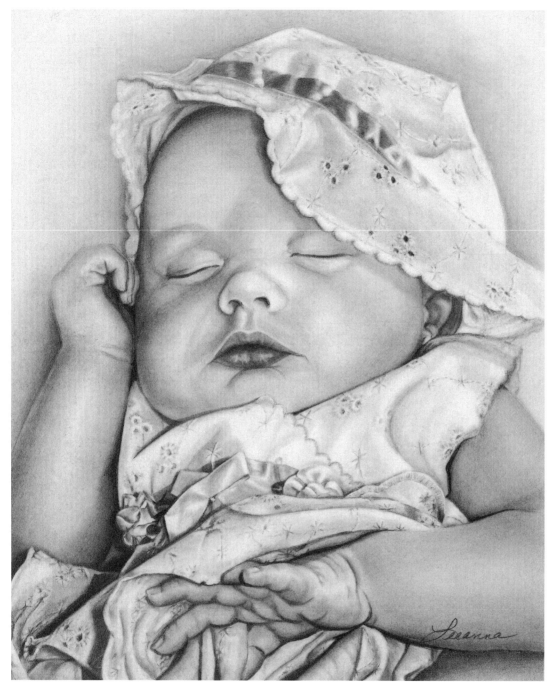

PORTRAIT OF BABY
Artist: Leeanna Lohmeier Pringle
Graphite on smooth bristol • 14" × 11" (36 × 28cm)

My friend Leeanna drew this portrait of her granddaughter in one of my classes. She did such a wonderful job on it, but I was most impressed with the way the fabric turned out. Each hole of the eyelet fabric was perfectly captured. You can see the light edge around each one and the illusion of the sewing, making it appear raised. The scalloped edge of the outfit looks so real; she even captured the seams. Look at the satin ribbons on both the bonnet and the dress. She used shading and the extremes of light and dark to make it appear shiny. This is the type of detail that I see many people avoiding, due to the labor intensive commitment it requires to make it work. While it certainly is not easy to create a portrait this good, it certainly is worth the effort if you do. A+, Leeanna!

Important Points to Remember

1 Observe the five different types of folds.

2 Study the way the fabric is being pulled and stressed.

3 Look for the light source and see how it affects the folds and creases.

4 Look for the hard edges where the fabric overlaps and the soft edges where it gently rolls.

5 Look for the reflected light and the shadow edges.

6 Use some background tone behind your subject matter if it will help create a more obvious light source.

7 Make sure that the pattern of the fabric is following the curves, folds and creases.

8 Remember to include the shading over the patterns to create shadows.

9 Practice!

10 Practice!

11 Practice!

10 How to Draw Hands

Hands add mood and feeling to a drawing. As seen in this portrait of Cayla, the hands take an ordinary portrait and turn it into a character study, a candid, unposed approach that reveals the subject's personality and what she is feeling.

This portrait grabs you with the mood it portrays. The pitiful expression, the sad eyes and the hands tell a story of complete despair. Cayla was just feeling left out that day, and I had a chance to capture her moment with the camera. Once I saw the photo, I just had to capture it as art!

Because hands are difficult to draw, many artists deliberately leave them out, which is a shame. They are missing out on some potentially awesome subject matter. Never shortchange yourself as an artist due to inexperience in a particular subject. Work on the problem and learn the skills.

Drawing hands is certainly a challenge, and you are not alone if you find them difficult. They are complex, with smooth transitions of lights and darks and many overlapping shapes. Because of this, I see a lot of similarities in drawing hands and drawing fabric.

Most of my students will simplify or eliminate the hands all together. When they do draw them, most will draw them way too round, missing out on the many angles that are always there. This results in the hands looking unnatural and rubbery. The drawings and demonstrations in this chapter will show you how to see the angles of the joints. Fingers are more angular than you may think, and are never completely straight. Even if a finger is outstretched, it still has subtle angles where the knuckles and joints create separate planes and geometric segments.

CAYLA'S MOMENT
Graphite on smooth bristol • 16" × 12" (41 × 30cm)

The angles and planes of the hand

Hands are really very angular in nature, not round and rubbery as we tend to portray them in our artwork. By comparing these line drawings with the angles blocked in to the fully rendered examples on the facing page, you can see how the joints and knuckles create various planes. By clearly defining these angles in your line drawing first, your hands will take on a more realistic form.

Keep your blending very gradual, and *never outline* the fingers.

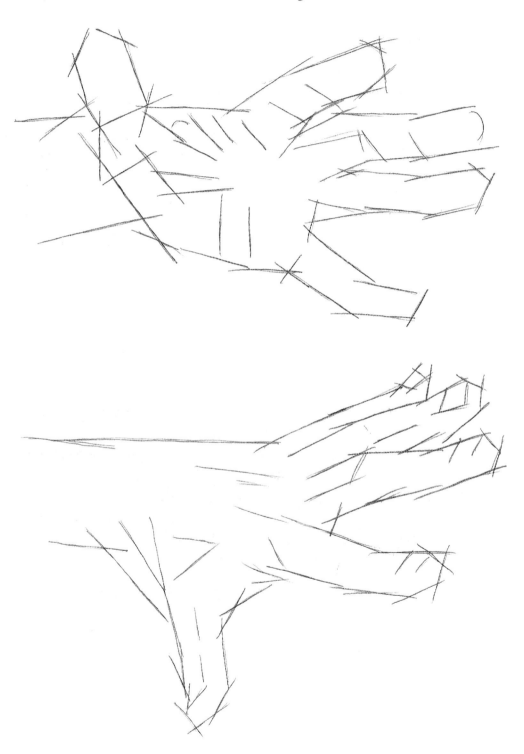

Allow the shading to create your edges. Always ask yourself, "Where is it light against dark and dark against light?" Look for the light areas that have been lifted out wherever the surface is somewhat raised.

The creases and lines in the hands are never harsh, but gently softened. The fingernails should be seen individually as shapes and the light and dark patterns studied on each. The hair on the tops of the hands and on the arms is put in last with very light, quick strokes.

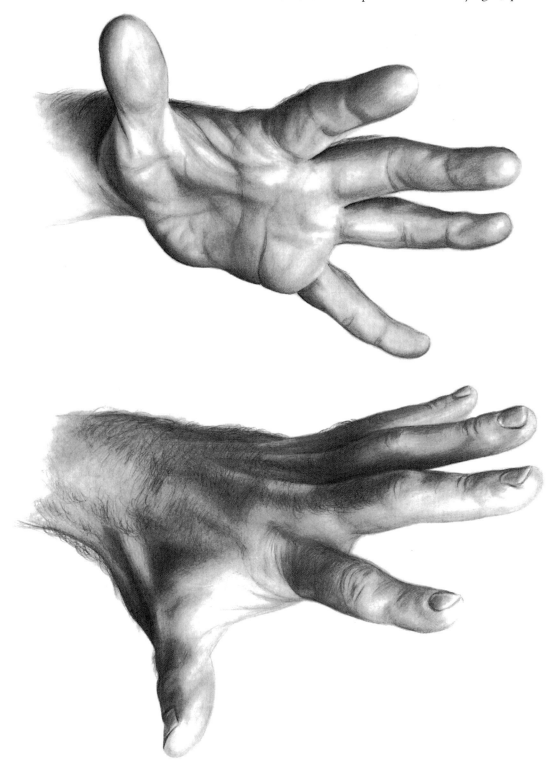

Comparing men's and women's hands

There are many differences between the male and female hand that can be seen clearly when the hands are placed side by side. Not only is the male hand larger in size, but it is also much "boxier" in nature. The fingers are thicker and more squared off.

The female hand is slender, with the tips of the fingers more tapered. The fingernails are generally longer and will protrude from the tips, adding to the tapered look. The relative absence of body hair makes female hands appear lighter in color.

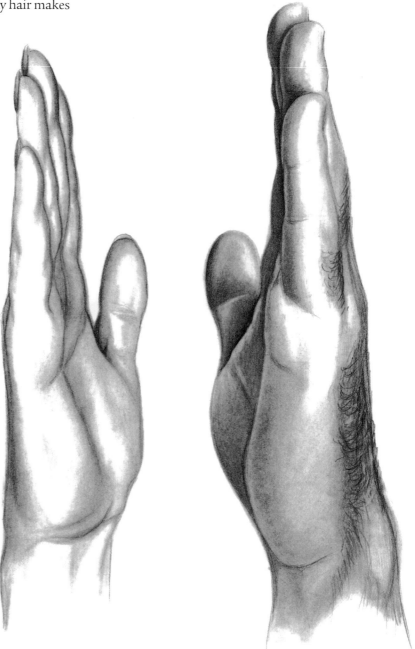

The female hand The male hand

Drawing the female hand

Outlining the hands is one of the most common drawing errors. By allowing the shades and tones to become edges rather than outlines, the hands will possess a more realistic quality.

The placement of tones on your line drawing is critical. It is here that you will see all of the shadows created by each finger and the subsequent areas of dark over light and light over dark.

It is very important to study each finger and where it overlaps another surface. You can then create the edges necessary to separate the fingers from the surface below. This is done by softening the edge into the surface in which it belongs. For example, look at the dark edge that defines the bottom of each finger. This dark edge should be shaded and softened into the finger rather than into the palm of the hand. This makes the dark area "belong" to the finger rather than becoming a shadow underneath. See how the reflected light creates the roundness of each finger?

Drawing hands step by step

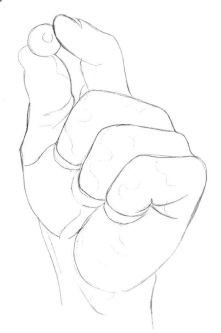

1 ANGLES AND PLANES
Your overall line drawing will be much more accurate if you keep the angle lines in mind while drawing. When you begin your shading, be sure not to lose these angles as that can make things appear too round.

2 ACCURATE LINE DRAWING
Use your graph to isolate all of the distinctive shapes of the hand. This is where you must accurately draw in the many angles created by the pose.

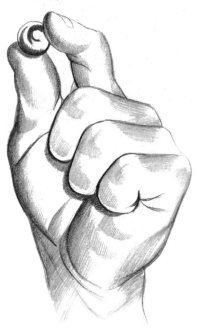

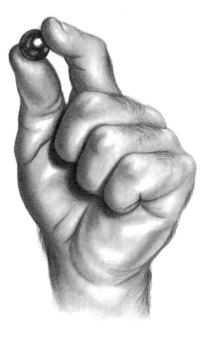

3 PLACEMENT OF TONE
Where is it dark? Where is it light? Place your darks carefully. Decide which "plane" they belong to. For example, is it a dark edge of a finger, or is it a dark shadow beneath a finger?

4 BLENDING AND LIFTING HIGHLIGHTS
Keep all blending extremely smooth. Blend your darks into the surface they belong to. Lift out highlights with your kneaded eraser. Be sure that reflected light is evident between the fingers to create roundness.

Wedding hands

Drawings of hands can make wonderful gifts. I collect photo references of hands and file them away just to use for gifts for anniversaries, weddings, and baby showers.

This drawing would be perfect for a wedding couple. It's even better if you can get a look at their rings and customize your drawing.

The exercises on the following pages will show you how to graph a photo to create your own hand drawings.

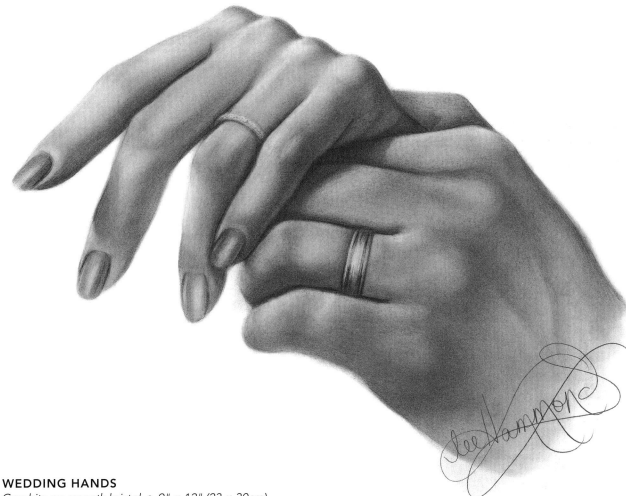

WEDDING HANDS
Graphite on smooth bristol • 9" × 12" (23 × 30cm)

Graphing and drawing the hand

This is an example of one of the most common hand and face poses used in portraiture. Use your 1-inch (25mm) acetate grid to practice from this example, keeping in mind all the information we have covered so far. Draw the entire photograph so you can study the relationship of the hand to the face as well as the shadows that are created on the neck and chest.

To keep the hand in correct scale to the rest of the features, remember that the hand is about the same size as the facial plane. Place your own hand over your face with the palm at the base of your chin. The tips of your fingers will reach to about the middle of your forehead. Stretch your fingers out, and the width between your little finger and thumb will be about as wide as your face.

By looking at the jewelry as just "shapes," see how convincingly you can render it. If you need to, use your ½-inch (13mm) grid to isolate the shapes more effectively.

Using the graphed photo as a guide, let's practice drawing the hand following the steps on the facing page. You can draw the photo in its entirety if you like, including the portion of the face as well. For now, I will be concentrating on just the hand itself.

1 ACCURATE LINE DRAWING

Using the graphed photo as a guide, draw the shapes of the hand. Watch for the angles of the fingers and the places where the joints and knuckles flatten out certain areas. Compare the edges of the fingers with the grid lines of the graph, and you can see the angles more clearly. You can still see my working lines in this example.

When you are happy with the accuracy of your line drawing, carefully remove the grid lines from your drawing paper with a kneaded eraser. Add the darker tones of the drawing, such as the fingernails and the tone in the background, with your pencil.

2 ADD TONE

Continue adding tone with the pencil, focusing on the shadow areas of the hand. Blend the background tone out with a tortillon.

3 BLEND THEN LIFT HIGHLIGHTS

Blend the tones of the hand with a tortillon. Add more tone with the pencil if necessary to further develop the shadows and hard edges.

Reapply some tone to the background to make it darker, and concentrate on the edges of the fingers against the background. All of them have reflected light along the edge.

Blend the tones of the hand until it looks smooth and realistic. Use a kneaded eraser to carefully lift the highlights and reflected light.

Do not overdraw the rings. Look at the photo, and you can see where the gold is reflective and where the dark areas are. The patterns of light and dark will create an illusion of metal and the overall shapes of the rings.

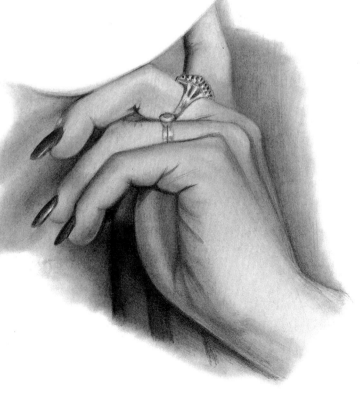

Drawing mommy and baby hands

Here is another project that is fun to do, and it will make a very special gift for a new parent. I recently drew one just like it for my niece and her new baby, and I enjoyed it so much, I thought I would offer it to you too.

1 ACCURATE LINE DRAWING
Use this graphed drawing to create an accurate line drawing. Work carefully, doing one box at a time, and remember to look for the angles.

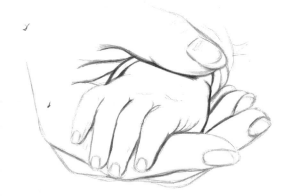

2 REMOVE GRID LINES
When you are happy with the results of your line drawing, carefully remove your grid lines with a kneaded eraser. Your work should look like this.

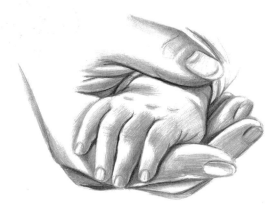

3 DEEPEN TONES
Apply the darkest areas of the drawing with your pencil, concentrating on the shadow edges and cast shadows caused by the fingers. Leave areas of reflected light along the edges. Do not outline and overdraw the fingernails. Look at where they are light and where they are dark.

4 BLEND
Carefully blend out the tones of the drawing with a tortillon. You can see here that there is not much white of the paper still showing. Look at how subtle the fingernails are. You don't see outlines around them—you see a dark edge where the nail recesses into the finger at the nail bed.

Look at the dimples in the baby's hand. Do not make them harsh like a line. They are subtle, with a small amount of reflected light around them to make them seem indented.

A small amount of shading in the background helps describe the edge of the hand and fingers. At the top left, the edge of the hand appears light over dark. Below, along the fingers, it appears dark over light. These lighting effects change as you go around the drawing, so study the lighting carefully.

Using hands as a focus

Hands can be used in portraiture to truly enhance the visual impact. Although a portrait of a child is always cute, this example shows how the hand can be the main focus.

This drawing is telling a story, which is what "illustration" is all about. It takes the audience into the work and allows them to form their own perception of what is going on.

This drawing would be a good one to practice from because of its size and clarity. It contains all of the important elements we have covered in the book so far, especially the five elements of shading and gradual blending. Study the drawing carefully for all the areas of reflected light along the edges of the fingers, the lower lid thickness and the ribbing of the sweater. These are the subtle nuances that will take your work from "okay" to truly professional.

I WANT MY MOMMY...
Graphite on smooth bristol • 8" × 8" (20 × 20cm)

A unique portrait

I love it when the unexpected happens with my artwork! I was using this portrait of John Lennon as a teaching demonstration in one of my seminars. We had all focused on the facial features, one at a time, and how to draw eyeglasses.

Once the features were complete, I added some of the darkness of the hair along the left side of the face. I then added some of the hair to the right side as well to show how important having some of those darker tones next to the face can be when trying to gauge your tones. The rest of the hair remained undone, for I was saving it for a later demonstration on how to draw the hair.

The drawing remained on my art table for the rest of the day, and many would look at it during their breaks. One of my students made a comment that changed the direction of the drawing completely. He said, "This drawing looks awesome just like this—unfinished. Just like John Lennon was." Wow! I found that observation so profound and so telling, I wanted to leave the portrait unfinished.

But as the days went by, another creative idea came to me. How about making it look like a work in progress, not just incomplete? I had a photo of my hand holding my favorite pencil, so the end result you see here was born. I drew my own hand into the drawing to make it appear as if I were still involved with it. But, to make sure the viewer realized that it was indeed finished, I put my signature in, as if it were coming out of my pencil. It is a good example of how a hand can enhance a drawing, even if it doesn't actually belong to the subject you are drawing!

It just goes to show that your artwork may surprise you. You don't always know what the final outcome will look like. Now when I look at this piece, I imagine it as it would look like if I had finished it completely, with all of the hair rendered in. While it would have been good, it would have lacked the creative interest that it has now. Don't be afraid to deviate from your original plan. Experiment with the unusual and see what magic can happen.

UNFINISHED BUSINESS
Graphite on smooth bristol • 17" × 14" (43 × 36cm)

Important Points to Remember

1 Be sure to see—and draw—the angles created by the joints of the hand to prevent an overly round, rubbery look.

2 Never outline the fingers.

3 Keep your blending very gradual.

4 Ask yourself, "Where is it dark, and where is it light?"

5 Look for the edges.

6 Look for the reflected light on each finger.

7 Hands can add visual impact to a portrait.

8 The size of the hands can be compared to the size of the face.

9 Men's hands are "boxier" than women's.

10 Never overdraw or simply outline the fingernails.

11 Practice!

12 Practice!

13 Practice!

11 Composition, Backgrounds and Special Effects

A portrait need not be limited to a single subject. Often the most expressive and revealing portraits involve two or more subjects. However, if you wish to add another subject, a background or a prop to your portrait, great care and consideration must be given to the placement of these things on your paper. They will strongly affect the overall balance of your composition. This chapter will give you some basic guidelines to follow as you begin to create more difficult pieces of work.

Since the subjects you want to draw are not always found together in the same photograph, this chapter will help you combine subjects from separate photos. Your creativity can be greatly enhanced when you aren't limited by your photo references.

Also, the ability to add interest through the use of special effects takes you from merely replicating photographs to truly creating art. This is when portrait drawing becomes exciting and fun to do.

You can see by the portrait at left that including all the surroundings can certainly help tell the story about your subjects. This portrait takes on a vintage look by including the entire scene in the drawing. This is true illustration, when the artwork tells a story through its elements.

ROGER AND SYLVIA WILSON, CIRCA 1959
Graphite on smooth bristol • 14" × 11" (36 × 28cm)

Composition

Composition is simply the way in which your subject matter is placed on the page. One of the hallmarks of good composition is balance. A well-balanced portrait is one in which there is not more "weight" on one side of the paper than the other nor too much space on either the bottom or the top. Not only do the shapes of your subjects need to be in balance, but the tones do as well. Too many darks in one area will weigh it down and take the composition out of balance.

There are four basic compositional shapes to keep in mind for portraiture: triangular, circular, square or rectangular, and diamond. These are the patterns created by the way you place your subjects on the page. If one of these shapes is the foundation for your work, the viewer's eye will be led around the page to the center of interest, or the focal point. Never allow the placement of shapes or the pose to send the viewer's eye outside of the picture plane.

The portrait below was created by taking two subjects from two different photos and placing them together on the page. It is a triangular composition because it gets wider at the bottom. The heads, even though they are at the same level, tilt in to one another, helping with the triangular shape.

I had the pleasure of meeting the Smothers Brothers, and they were nice enough to sign my drawing. The triangle was further helped by the signatures that were added after the drawing was finished.

Diamond

Circular or oval

Square or rectangular

Triangular

Each compositional shape can have any number of subjects in its arrangement.

THE SMOTHERS BROTHERS
Graphite on smooth bristol • 11" × 14" (28 × 36cm)

Multiple subjects

It's not necessary for the subjects you're drawing to be in the same reference photo, but there are certain guidelines you should follow when combining photos.

1 Make sure the lighting is consistent in both photos. If the lighting does not come from the same direction in each photo, the shadows on the faces will not match. Although it is possible to alter the lighting, it may be difficult, since shadows will alter the appearance of shapes.

2 Have your subjects looking in the same general direction. You can change the direction of the eyes by moving the placement of the irises.

3 Create a composition with the placement of your subjects. Use one of the four compositional shapes shown on the previous pages.

You can combine subjects from different photos even if they're not the same size. Start with the largest subject first, and measure the distance from the mouth to the eyes. Then try to make the other subjects conform to those measurements.

If the subjects are of different ages, remember the natural size differences and adjust your drawing accordingly. For example, if you're putting a photo of a small child with that of an adult, find out how much smaller the child's head would be in real life, by either measuring from photos of the two together, or by looking at them together side by side.

GUATEMALAN MOTHER AND CHILD
Graphite on smooth bristol • 11" × 14" (28 × 36cm)
Art created from a photo provided by Kristen Jaloszynski

This is an adorable pose, and it certainly breaks the rules of compositional placement. But the drawing works because it is balanced. The eyes of the mother looking over at the child leads the viewer's eye to the middle. This helps the distribution of weight. If both of the subjects were looking at you, and placed side by side, it would not have the same effect.

AFRICAN FATHER AND CHILD
Graphite on smooth bristol • 14" × 17" (36 × 43cm)
Art created from a photo provided by Kristen Jaloszynski

I had to correct the positioning when creating this piece. In the original photo, the subjects were reversed, with the baby on the right. They were actually leaning away from each other. By switching them and placing the baby on the left, they come together perfectly. This makes a much more pleasing composition.

Simple backgrounds

Sometimes leaving a portrait simple with very little background gives the artwork more impact. This drawing of John Walsh, from the television program "America's Most Wanted," is striking just by the expression alone. It required no special effects, background treatments, or supplemental subject matter for this to capture your attention. The expression does it all. A hint of shading in the background is all it needed.

JOHN WALSH
Graphite on smooth bristol • 14" × 11" (36 × 28cm)

Use your surroundings

When my children were younger, we were going for a walk at a nature center. I always have my camera with me to take photos of nature, animals and flowers, but also to capture candid shots of my family. My son was about twelve at the time, and was off by himself observing something going on in the park. I immediately saw an opportunity for a great photo.

When I looked at the photo later, I was struck not only by the pose and how well it captured my son's persona, but I was taken by the patterns created by the intense shadows. The light coming through the trees that day cast such interesting shapes onto Christopher. The result was not only a portrait of him, but a study of the surroundings as well.

Look at how intense the shadows are on his face. As glaringly apparent as the shadows are, they look perfectly natural due to the rest of the background being included. The illusion of the trees in the background helps complete the scene.

The lighting is the most important aspect of this drawing. Look at how it plays off all the surfaces. The textures and forms are enhanced by the light dancing off of them. Look at the way the light makes the texture of the tree bark look rough. Look at the folds and creases of Christopher's shirt. The lighting enhances the tubular folds, making them much more obvious. Notice how the pattern of his shirt is seen through the shadows and lighting, adding to the look of realism.

An important rule to follow when doing a drawing such as this and the one of the couple on page 146 is that only one "plane" should be in focus. Think of how your actual eyesight works: if you focus on something, everything else goes out of focus. By making the background appear a bit blurred, the focus stays on the main subjects.

CHRISTOPHER IN THE WOODS
Graphite on smooth bristol • 14" × 11" (36 × 28cm)

Border boxes and cropping

Cropping is a creative technique that involves framing the drawing within a border, and it is an effective way to dramatically present your subject. On the portrait below of a daddy with his baby, the border actually cuts off some of the image, allowing very little background to show. The result is that your full attention goes straight to the center of the drawing and "the kiss."

This is a similar look to that of the segment drawing exercises on page 95, but this time, the entire subject is seen within the box. The border drawn around the subjects is very thin. It contains the drawing without competing with it.

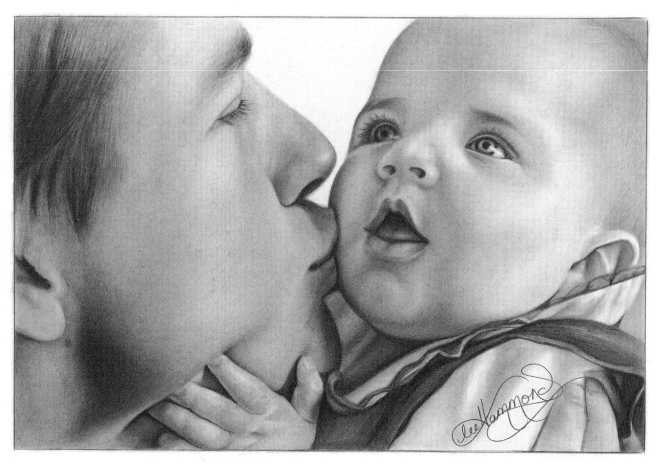

DADDY SCOTT AND KIRA
Graphite on smooth bristol • 9" × 12" (23 × 30cm)

This portrait of Clark Gable shows how a border box can be used to simply enhance a subject. The head is protruding outside of the box, but the box stops at both shoulders. The shading coming from the inside edge of the box leads your eye directly to the subject.

Experiment with border boxes and see how many variations you can come up with to further enhance your portrait work. You can draw a border as subtle or as wide as you like. Be sure to use a good straight edge or T-square to make it clean and perfectly measured. Do it right the first time, because it is hard to alter a heavily drawn line that is not right. It can ruin a good drawing.

CLARK GABLE
Graphite on smooth bristol • 17" × 14" (43 × 36cm)

Creative backgrounds

The use of a background can play an important part in the visual statement you want your work to express. You can give it a soft, calm look or liven it up with a graphic, energetic approach. Either way, you should be sure that it works with your subject matter and never takes away from it.

Concentrate on the lights and darks of your subject when selecting a background treatment. If the subject is very light on one side, some dark tone behind it will show the contours more clearly. Always pick a background that will show off the contrasts. I use the "light against dark" and "dark against light" guideline.

I drew this for my sister when she joined the Air Force. The background is a unique way to make a statement about her and convey a patriotic sense.

CATHI
Graphite on two-ply bristol • 14" × 11" (36 × 28cm)

Making a montage

Sometimes you will want to create a very complex piece. This is an example of what I call a *montage*, and it shows how you can take multiple photos and put them together into one "superdrawing."

A montage is not to be confused with a *collage*. A collage is created by taking separate photos and items and pasting them together into a grouping. A montage is taking a collection of images and drawing them together.

A montage is a nice way of telling a story about someone, depicting their life and special moments through your artwork. This drawing is one I did for my oldest daughter. It is a collection of her childhood photos at varying stages of her life. Each image is a portrait in itself, and it creates a memory of the child as she was at that point.

Make sure you make a project like this somewhat large. The smaller a drawing is, the harder it is to draw and to make it accurate. I made mine 24 x 18 inches (61 × 46cm), so I could make each image as large as possible.

I am doing a montage for each of my kids, and I always include a drawing of myself in the upper right. That way all the montages, although very different, have the same feel to them.

Go through your photo albums and see what memories you can capture. Special memories mean even more when you hand-draw them. Be careful of what pictures you select, though. I was so sure that Shelly would laugh when she saw the one with her hands behind her back. That was a secret sign we had for one another when she was little. When I would ask her how much she loved me, she would stretch her arms way in back of her and say "This much!" When she saw the drawing she didn't remember that and wanted to know why her arms looked disconnected. Well, it means something to me!

THE LIFE OF SHELLY ANN
Graphite on smooth bristol •
24" × 18" (61 × 46cm)

SWEET REMEMBRANCE
Graphite on smooth bristol • 17" × 14" (43 × 36cm)

This is one of my all-time favorite drawings. Its sweet impressions and softness make me smile every time I look at it, for it brings back such wonderful memories of my daughter Shelly.

This is another example of using subtle backgrounds. Because she had on a white shirt, I really needed something to make the edges show up. I used the rule of thumb about shading: "light against dark" and "dark against light."

By placing something dark against something light or white, the edges can be described without outlining them.

Notice how I did not take the shading of the background up above the head. Sometimes doing that can weigh the entire portrait down, unless the entire background is filled in dark.

Important Points to Remember

1 Your artwork should be balanced both by shapes and by tones. Use one of the four general compositional shapes: triangular, oval or circular, square or rectangular, or diamond.

2 Never let the subject matter or composition lead the viewer's eye outside the picture plane.

3 Portraits are posed; a character study is candid.

4 When combining subjects from different photo references, look for three things: size relationships, consistent lighting and eye direction.

5 Background treatments should enhance your work, not compete with it.

6 Use light against dark and dark against light tones in your background.

7 Do not shade above the head—it will weigh the subject down.

8 Eliminate unnecessary subject matter that may be in your photo so it does not detract from your center of interest.

9 Cropping your artwork can create an interesting and dramatic portrait.

10 Practice!

11 Practice!

12 Practice!

Index